LEGENDARY LOCALS

—— OF ——

THE PUYALLUP
VALLEY

WASHINGTON

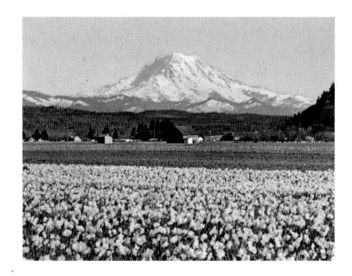

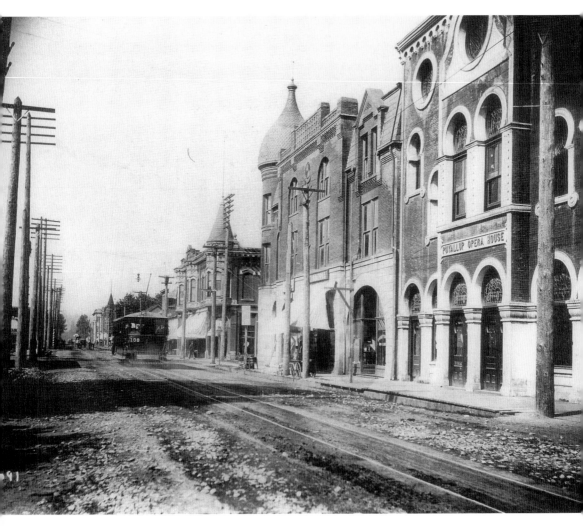

Puyallup Street Scene, 1890s
In the 1890s, Puyallup's Meridian Street boasted an opera house, a streetcar, and electricity. The opera house would later host the city offices. (Courtesy of Puyallup Historical Society.)

Page 1: Puyallup Valley Daffodil Field
Fields of daffodils once adorned the valley floor. Mount Rainier, an active volcano, provides a most fitting backdrop to all valley activity. (Photograph by Clifford B. Ellis, courtesy of Wes and Suzy Perkinson.)

LEGENDARY LOCALS
— OF —

THE PUYALLUP VALLEY

VALLEY

WASHINGTON

RUTH ANDERSON

LEGENDARY
LOCALS

Legendary Locals is an imprint of Arcadia Publishing
Charleston, South Carolina

Printed in the United States of America

Library of Congress Control Number: 2013932433

For all general information, please contact Arcadia Publishing:
Telephone 843-853-2070
Fax 843-853-0044
E-mail sales@arcadiapublishing.com
For customer service and orders:
Toll-Free 1-888-313-2665

Visit us on the Internet at www.arcadiapublishing.com

On the Front Cover: Clockwise from top left:
Ronimous Nix family of pioneers (Courtesy of Puyallup Historical Society; see page 18), Marcus Porter, common man's attorney, (Courtesy of Puyallup Historical Society; see page 55), Dr. Donald and Beret Mott, philanthropists (Courtesy of Mott family; see page 98), Candace Blancher, fair board member (Courtesy of Candace Blancher; see page 111), Newell Hunt, furniture store owner (Courtesy of Kiwanis Club of Puyallup; see page 61), Debora (Stein) Munson, art teacher and promoter (Courtesy of Jenifer Ross; see page 109), Pfc. Mark Porter (Courtesy of Betty Porter Dunbar; see page 83), Dr. Warner Karshner (Courtesy of Paul H. Karshner Memorial Museum; see page 94), Brittney Henry, Miss Washington 2011 (Courtesy of Brittney Henry; see page 111).

On the Back Cover: From left to right:
Ezra Meeker, pioneer, and Avard Fairbanks, sculptor (Courtesy of Puyallup Historical Society; see page 14), Puyallup Fire Department in 1930 (Courtesy of Paul H. Karshner Memorial Museum; see page 78).

CONTENTS

ACKNOWLEDGMENTS

Historian Hans Zeiger researched and wrote about several of the people in this book who otherwise would have been left out if not for his dedication. I am also grateful to Meeker biographer Dennis Larsen, and Jerry Bates, South Hill Historical Society, for their inputs. Hans and Puyallup Historical Society president Bob Minnich served as the editing team, and they have my deepest gratitude. Sarah Beals carefully scanned the majority of the photographs, ensuring they met the publisher's specifications. Her expertise and flexibility made this task much lighter.

In the 1970s, members of the Ezra Meeker Historical Society contacted as many longtime valley residents as they could locate and asked them to provide written memoirs of their families. Lori Price, newspaper reporter and official Puyallup historian, prepared hundreds of columns from these writings, titling them "Pacemakers." Biographies of the historic figures in this book draw heavily on the original writings and Lori's synopses.

Janice Baginski and Suzy Perkinson of the Puyallup Historical Society, who have professionally organized the society files, volunteered their assistance in locating materials and photographs, thus making this book possible. Society members Wayne Fass and Jenny Canter also researched and scanned photographs. Heritage Quest Press, Orting, and McCutcheon's Studio, Puyallup, kindly donated copies of photographs from their collections. Beth Bestrom, Paul H. Karshner Memorial Museum, and Beth Schwartzbaugh, Puyallup Public Library, ably and amicably directed research of their files and photographs.

Numerous families granted interviews and provided photographs of ancestors or of themselves. I am very appreciative of their time and interest. Materials gleaned from this effort will now be placed in the permanent files of the historical society.

Finally, my special thanks to Puyallup Historical Society historian Andy Anderson for suggesting content, chasing facts, taking photographs, preparing the layout and index, and cooking my nightly supper.

If you find any errors in the book, the responsibility is solely mine, but please let the Puyallup Historical Society at Meeker Mansion know so that we can correct the historical record.

Unless otherwise indicated, photographs are courtesy of the Puyallup Historical Society at Meeker Mansion.

INTRODUCTION

The Puyallup Valley occupies a J-shaped stretch of land in western Washington, towered over by the most legendary local in the Northwest, Mount Rainier. Lahars from this volcanic uplift created the valley, whose hills are filled with glacial rock, while some of the valley soil is rich and deep.

Several thousand years ago, indigenous tribes arriving from the north liked what they found in this verdant valley. Here, along the river that empties into a large bay, they fished for salmon, dug edible roots, and picked berries and nuts. In this valley, they became known as generous or welcoming people, a Salish-language word shortened to make the sound of Puyallup.

Into this heavily forested land came the white man. British naval captain George Vancouver was the first recorded European to sail into the body of inland waters, arriving in 1792. He named the sound for one of his own officers, Lt. Peter Puget, and Mount Rainier after a British naval admiral. Unknown numbers of trappers steadily moving West spent their lives pursuing the wild fauna, and American explorers Lewis and Clark followed the Columbia River, wintering on the south bank in 1805–1806.

The British Hudson's Bay Company established Fort Nisqually in the Nisqually River delta in 1833, and within five years, American missionaries began to arrive. In 1846, the British and American governments agreed that the US boundary would be at latitude 49 degrees. Two years later, Congress created the Oregon Territory, which included the current boundaries of the state of Washington.

In 1849, the US Army built a simple log-structure "fort" in Steilacoom on Puget Sound, manned by a modest military contingent. The next year, Congress enacted the Donation Land Act that allocated 320 acres of federal land each to settlers (640 for a married couple), provided the claim filers would improve on the property. The promise of free land encouraged people of all walks of life to sell their farms, stores, medical and legal practices—whatever they had—and to secure a team of oxen or mules with a wagon that could ford rivers in order to travel West.

The great migration over the Oregon Trail from Missouri to the West Coast lasted from the 1840s to the turn of the 20th century. The early settlers in our story primarily arrived after a grueling six or seven months on this 2,000-mile journey. As the Willamette Valley in Oregon filled with settlers, the land to the north claimed increasing attention.

Pioneers who first ventured into the Puyallup Valley faced the daunting task of downing trees, clearing thick brush, and uprooting stumps in order to plant sustaining crops. The first time Ezra Meeker, who would become Puyallup's first mayor, forged his way into the area, he dismissed any possibility of making it hospitable, so foreboding were the forests. But settlers did begin to populate the area, staking claims and planning their future. Alas for early settlers, forces beyond their control would put a temporary halt to their activity.

Washington Territory was carved out of the Oregon Territory in 1853, and a self-promoting US Army officer named Isaac I. Stevens was appointed governor to oversee the new region and to negotiate treaties with the natives. (Donation land claims could not be properly allocated until title to the land was in the hands of the US government.) Local Indians had welcomed the pale-faced men of the Hudson's Bay Company who introduced guns and numerous other useful items as barter for Indian-provided food and scouting support. But increasing encroachment from "Boston" people spelled trouble. The treaties Stevens began negotiating were unabashedly one-sided, relegating native peoples to inadequate reservation space. Nor were there attempts by the US government to halt settlement on lands the Indians were allocated.

For many reasons, including differing concepts of land ownership and treaty observance, natives were angered. In mid-September 1855, the Indian War began with the ambush of white men traveling into eastern Washington. Other Indian raids followed, including the massacre of nine settlers in the White

River area in October. Had it not been for the actions of Abraham Salatat, a Native American, who bravely traveled from farm to farm warning of an impending attack, there would have been more killed.

More than 80 settlers heeded Salatat's alert, grabbed what they could, and fled for the safety of Fort Steilacoom. US Army regulars and citizen militia put down the rebellion within a year, but not without loss of life and trust on both sides. When settlers returned to their claims, most found their buildings destroyed, the livestock gone, and the fields in need of rehabilitation. But they had not slogged over the Oregon Trail to let go of their dreams. With the Indian troubles behind them, they rebuilt, cleared more land, and invited family members and friends from back East to join them.

The valley story begins with biographies of two Native Americans of great stature and importance—Nisqually chief Leschi and Puyallup Tribal Council member Henry Sicade. Both helped seal the fate of the people whose ancestors lived and prospered here long before the white men knew this piece of paradise existed.

Because of space limitations, the book focuses on individuals from Puyallup, with a few legends from Orting, Sumner, and South Hill. The book is not a chronology, but instead a compendium of individuals engaged in like activities from all eras. The contents move from the brave and hardy Oregon Trail immigrants who settled the valley, to commerce, which began with manufacturing timber products, raising fruits and vegetables for the market, and providing retail and services to growing populations.

In each town, men and women, then and now, have spent untold hours serving state government, town councils, and school and transportation boards, and engaging in fundraising to establish medical facilities, youth activity opportunities, and the like. Educators and doctors continue to serve their community, and the arts, clubs, and sports have flourished from the beginning with far too many notables to include them all.

As the reader will discover, several of the entrants are still among us, some from multigenerational valley families, engaged in activities that sustain, protect, and enhance our lives.

CHAPTER ONE

Settling In

Chief Leschi, born in 1803, exemplifies the generation of native peoples who were most affected by the invasion of men and women whose culture proved vastly different. The new language, customs, and beliefs all defied known tribal convention in the Northwest. Leschi's frustration naturally led him to try to at least mitigate the onslaught. Leschi's grandnephew Henry Sicade on the other hand, adapted to the white culture more readily while remaining well liked by his tribe.

James Stewart, a young farmer and schoolteacher, filed the first land claim following the Indian War. Ezra Meeker returned in 1862 and platted a town on part of his claim in 1877 and named it for the local tribe, a most fitting name given the history of the community's generosity that ensued. The town of Puyallup was officially incorporated in 1890. Orting at the south end of the valley incorporated in 1889, Sumner in 1891, and South Hill remains an unincorporated Census Designated Place.

Sumner derived its name in an interesting manner. From Amy Ryan's book *The Sumner Story*, readers learn that George Ryan, Levant Thompson, and Joe Kincaid met in Kincaid's store, and each put a name in a hat. A passing boy drew the slip that read, "Sumner," a tribute to US senator Charles Sumner, a popular civil rights advocate of the era. When the town was incorporated, the name was placed on the railroad depot.

After the Washington State Constitution approved establishment of a soldier's home, a board of trustees was appointed to locate an appropriate site. Orting town fathers lobbied hard and gained approval over Puyallup and other contenders to situate the home on acreage east of town. In 1891, dignitaries arriving by train dedicated the Soldier's Home, a three-story frame building with offices, dining facility, and sleeping quarters, situated on 185 acres. The Washington Soldiers Home and Colony is still in use today, a tribute to Orting's visionaries.

While some of the settlers were, like Ezra Meeker, formally uneducated, others, such as George Whitworth, came with college degrees. Whatever their station in life had been, the men and women who carved communities out of the forests garner great respect for the hardships they endured.

But all was not work. In 1900, a group of entrepreneurs and farmers gathered to start a fair that would become the fifth largest in the nation today. From its modest beginnings with $81 pledged for a three-day opportunity to showcase valley agriculture and industry, the enterprise steadily grew, shutting down only during World War II. As we go to press, the Puyallup Fair has been renamed the Washington State Fair, but for purposes of this book, it shall be known simply as the fair. "Do the Puyallup" will remain its slogan.

Leschi, Nisqually Indian Chief

Born in 1803 to a mother with ties to the Yakima Nation and a Nisqually father, Leschi, who left no photograph, is one of the most famous Native Americans in the Northwest. Leschi and his brother Quiemuth raised horses along the Nisqually River that they sold to the Hudson Bay Company headquartered at Fort Nisqually. By all accounts, white traders, settlers, and US Army soldiers got along well with this prominent man, who traded fairly and posed no threat, until the Medicine Creek Treaty of 1855 came along. Whether Leschi signed the treaty with his own "X" is a matter of conjecture, but it is clear that he was not satisfied with the reservation area set aside for his people. When negotiations failed him, he began assembling other natives to take action. In October 1855, Leschi and Quiemuth learned that a militia unit was riding out to capture them so they fled. On Halloween, a group of natives attacked a seven-man militia unit returning from Yakima, fatally shooting Abram B. Moses. Gov. Isaac Stevens accused the Nisqually brothers of the deed and offered a reward for their capture or death. Leschi's nephew Sluggia betrayed his uncle. Quiemuth surrendered but was summarily murdered by an unidentified assailant while in custody. Leschi's first jury, composed entirely of white men, failed to convict Leschi, but Stevens kept him imprisoned and successfully retried him, and Leschi was hanged near Steilacoom on February 19, 1858. Many white people abhorred the injustice of the hanging, and over time, Leschi's name could be found on many neighborhood parks, schools, and streets in the region. Finally, in 2004, at the behest of the Washington State legislature, a Historical Court of Inquiry exonerated Chief Leschi. The monument that stands on the location of his hanging can be found in a shopping center in Lakewood.

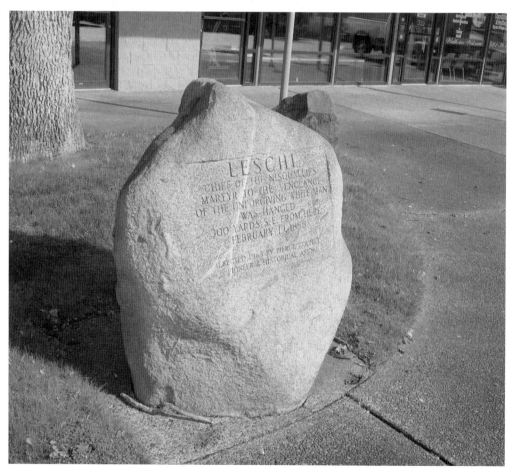

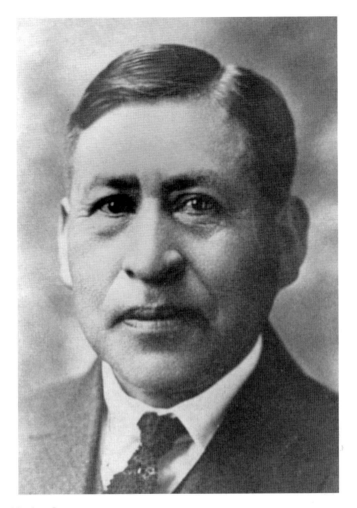

Henry Sicade, Native Son

Henry Sicade is this book's first Renaissance man. Born to a highly respected Nisqually Indian family in 1866, Henry attended the first Indian school in the area and finished four years of college in three. Equally at home with his own people or giving speeches about them to white audiences, Henry embodied the best of his culture and availed himself of American institutions that propelled him beyond the reservation. By Henry's account, Nisqually Indians tended to become leaders of tribes, even when they moved to other areas. Henry's maternal grandfather was a Puyallup Indian chief, and Leschi was his granduncle. Like his forebears, Henry rose to leadership positions wherever he ventured. In 1899, he helped found the Fife Public School System, which he later served as a director. From age 17, he held a seat on the Puyallup Tribal Council and was later elected to the Fife City Council. When the US Army needed someone to appraise some of the property being purchased for the establishment of Camp Lewis prior to World War I, Henry's fair and accurate estimates were all accepted. Even though he had inherited nothing from his parents, Henry's business acumen enabled him to overcome setbacks and become a wealthy landowner in the valley, which, in turn, aided the community. He donated property for the Congregational church, secured tribal lands and funds for an Indian cemetery, and routinely fought for federal funding for reservation needs. Henry was married to Alice Lane, daughter of the last Puyallup Indian Chief Thomas Lane, and the couple had eight children, seven of whom lived to adulthood. Henry's death in 1938 came far too soon for his family, his tribe, and the many white people who had found in him a great champion of justice, equality, and industry.

Willis and Mary Ann Boatman, 1852 Pioneers

Willis was 25 when he brought his 18-year-old wife over the Oregon Trail to Portland in 1852. Migrating north to Steilacoom, the couple took a land grant in the Puyallup Valley in 1854. That year, Mary Ann gave birth to their second son, John William, the first white child born in the valley. Soon after the Indian War, the family returned to the valley, and Willis became a prosperous hop grower. In 1889, he founded the Puyallup State Bank, the first in the city.

Monument to Indian Salatat

Salatat apparently did not believe that white settlers should face attack, so he warned people living in the valley to leave before an assault on them could be launched. The monument pictured sits on North Levee Road, next to the Meridian Street Bridge.

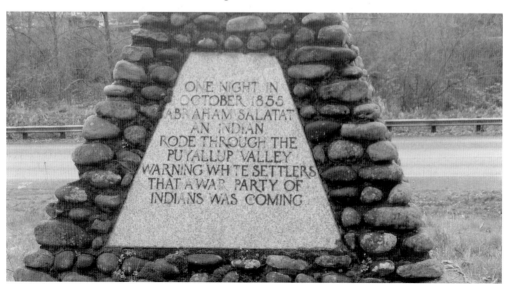

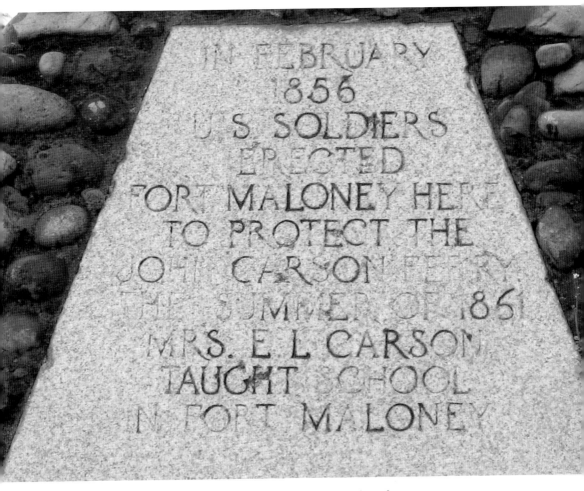

IN FEBRUARY
1856
U.S. SOLDIERS
ERECTED
FORT MALONEY HERE
TO PROTECT THE
JOHN CARSON FERRY
THE SUMMER OF 1861
MRS. E L CARSON
TAUGHT SCHOOL
IN FORT MALONEY

John and Emma Carson, First Ferryman and First Schoolteacher

Regrettably, no photograph can be found of John and Emma Carson; however, not only does this monument honor Indian Salatat but also the Carsons. John claimed land on the Puyallup River near the current Grayland Park, which was then along the river. From his property, he cobbled together a ferry in 1853 to enable pioneers to cross the river to King County and the northern military forts. When the Indian troubles erupted, John barely escaped attack. To provide better access to the valley in this dangerous time, the US Army built a blockhouse on the opposite side of the river from Carson's log home and called it Fort Maloney. After the war, the Carsons returned and erected a toll bridge at the site, the first of several that washed away. Emma (Darrow) Carson, a well-read woman, was the first schoolteacher, holding classes in 1861 in the Fort Maloney blockhouse. The Carson chestnut tree, beside the intersection of Meridian Street and State Highway 167 and now under state protection, is all that remains of their place.

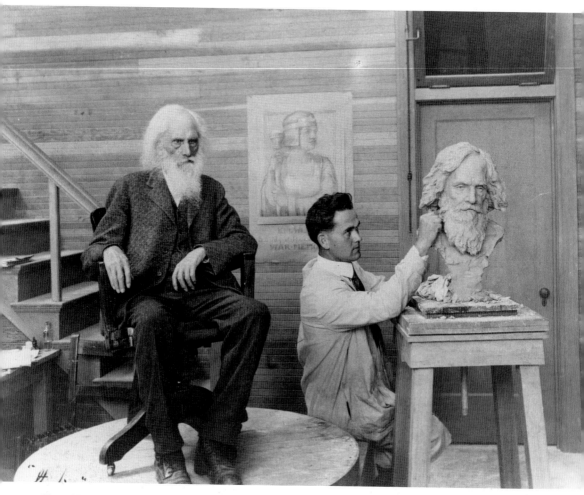

Ezra Meeker, Puyallup's First Mayor, and Avard T. Fairbanks, Sculptor

Ezra Meeker was born in Huntsville, Ohio, in 1830. In 1851, Meeker married Eliza Jane Sumner, and the next year, the couple and their first of five children headed West with Ezra's brother Oliver over the Oregon Trail. The family settled in the Puyallup Valley permanently in 1862, where for the next 30 years, Ezra farmed, primarily growing hops, which eventually brought the Meekers enormous wealth. Meeker championed schools and libraries and dabbled in shopkeeping and businesses that enhanced the growing town. In 1857, he sat on the first trial of Nisqually Indian Chief Leschi, voting for acquittal, which he later wrote about in his book *Pioneer Reminiscences*. In the late 1880s and early 1890s, the couple was much involved in the women's suffrage movement. At the height of his prosperity, Meeker invested heavily in his community's infrastructure, including the Meeker Mansion that cost the heady sum of $26,000. In 1890, Meeker was elected first mayor of the newly incorporated city of Puyallup. Meeker went bankrupt when hop lice invaded local crops but recouped some funds shipping food products to Dawson City at the height of the Klondike Gold Rush. (Biography courtesy of Dennis Larsen.)

Ezra Meeker Standing on Wagon Tongue, Oregon Trail Preservation Trip, 1906
The last 23 years of Meeker's life were spent working to preserve both the history of the old Oregon Trail and the physical remnants of the trail that still remained. In January 1906, at age 75, Meeker started east from his home in Puyallup with an ox team and covered wagon. At towns along the way, he arranged for the erection of stone markers to memorialize the trail and pioneers who traveled it. He drew large crowds everywhere he went, including on Broadway in New York City. In November 1907, Meeker met Pres. Teddy Roosevelt. Meeker again hit the trail with ox team and wagon in 1910–1912, and in 1916, he traveled in an 80-horsepower Pathfinder automobile fitted with a covered wagon top, perhaps the nation's first recreational vehicle. In 1924, he flew as a passenger in an open-cockpit US Army plane from Vancouver, Washington, to Dayton, Ohio, and on to Washington, DC, where he presented Pres. Calvin Coolidge with a plan to build a national highway following the route of the Oregon Trail. In 1926, he founded the Oregon Trail Memorial Association and made yet another trip over the trail in a touring automobile. Meeker died at 97 in 1928, planning yet another motorized trip over his beloved trail. (Biography courtesy of Dennis Larsen.)

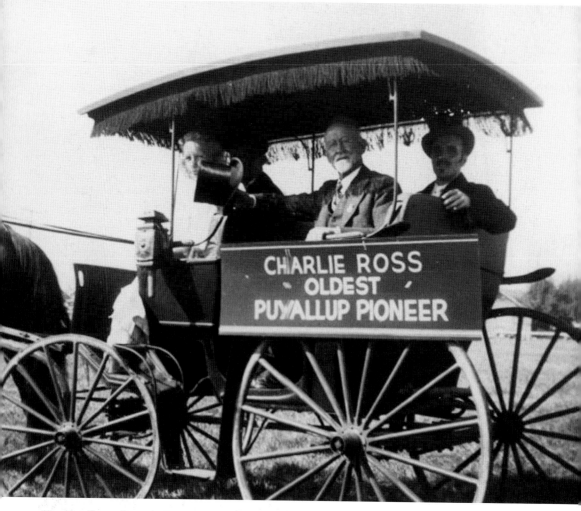

Charles Ross, Oregon Trail Baby

Charlie was born to trail pioneers Darius and Eliza Ross near Meacham, Oregon Territory, on September 3, 1851, and the family settled in Puyallup 13 years later. Charlie, a teacher, donated 20 acres of land, as did his father, to enable establishment of the Washington State Experimental Farm in Puyallup. Well known throughout the state, Charlie was selected to present Pres. William McKinley with a basket of Washington fruit at the Pan-American Exhibition in Buffalo, New York, on September 6, 1901. Unfortunately, McKinley probably had no chance to sample the offering for that very day he was felled by an assassin's bullet and died eight days later. In July 1923, Charlie sat on a platform with Pres. and Mrs. Warren G. Harding at a pioneer celebration in Oregon. Less than a month later, Harding mysteriously died in California while still on his western tour. Undaunted by these ominous encounters with national leaders, Charlie lived to the ripe age of 96, a revered pioneer to the end.

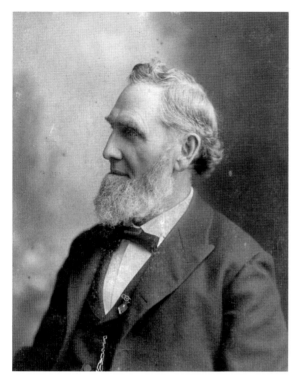

John Valentine Meeker, Early Teacher

John V and his wife, Mary (Pence), came West via ship in 1859 to join his father and younger brother Ezra. The next year, the couple filed a Donation Land Claim in what is now downtown Puyallup, and John started teaching. Later, he held the positions of county surveyor, county superintendent of schools, and county commissioner. John and Mary Meeker also built a spacious home for their six children, which, over the years, has changed hands several times but still graces the downtown area.

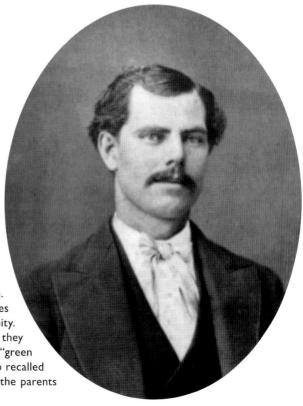

Charles Field, Mineralogist and Schoolteacher

Charles, tangentially related to John Meeker, heeded John's advice and arrived in Puyallup in 1884 to join the 389 people then living in the town. Charles was a Civil War veteran and mineralogist by profession. Here, he engaged in retail businesses and wore several hats for the community. His wife, Agnes, taught in the building they lived in that came to be known as the "green school." The couple had four children who recalled playing hide and seek in lodge halls while the parents attended meetings.

Ronimous Nix, Early Real Estate Magnate

Ronimous Nix, quintessential valley pioneer, left his Pennsylvania home at 16 to join a wagon train headed West. By 1855, he had staked a Donation Land Claim on acreage that today hosts the Linden Golf Course between Puyallup and Sumner. He retreated to the fort during the Indian War and signed on as a volunteer with the militia. Following the war, he returned to his plot, cleared the land, and began raising crops. Nix married three times, first in 1863, to a half-Indian, half-French Canadian woman named Catherine, who left him in 1882 to return to her people with their youngest daughter after one young son accidentally shot his brother to death, a tragedy Ronimous blamed on Catherine; to the "Meyer girl" that same year who died in childbirth; and the next year, to Minnie (Teitzel), the daughter of German immigrants. Ronimous provided well for his large family by growing hops and other crops, and he had the largest herd of cattle in the valley. With a good business sense, he bought properties and extended mortgages, at one point owning 30 homes in the area.

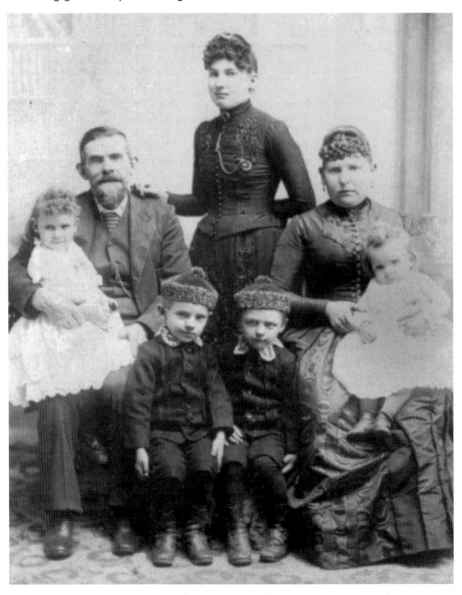

Alexander Campbell, City Council Buff

Alexander C. Campbell so thoroughly enjoyed serving on city councils that, at different times, he was elected to those of Tacoma, Steilacoom, and Puyallup. In April 1889, Campbell was elected chair (de facto mayor) of the fledgling Puyallup City Council, but in February 1890, the Washington State Supreme Court declared the council corporation illegal. On August 19, 1890, the secretary of state signed proper incorporation documents, thus giving official birth to the City of Puyallup.

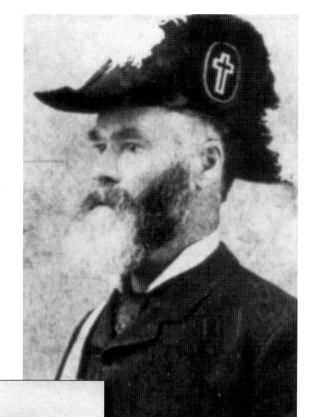

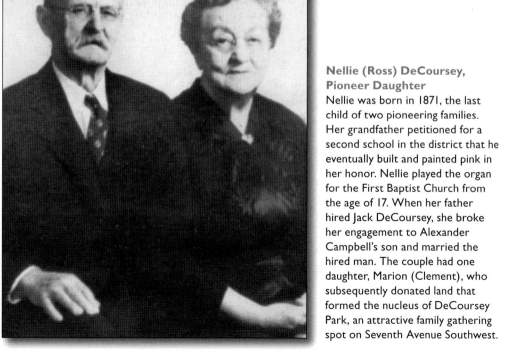

Nellie (Ross) DeCoursey, Pioneer Daughter

Nellie was born in 1871, the last child of two pioneering families. Her grandfather petitioned for a second school in the district that he eventually built and painted pink in her honor. Nellie played the organ for the First Baptist Church from the age of 17. When her father hired Jack DeCoursey, she broke her engagement to Alexander Campbell's son and married the hired man. The couple had one daughter, Marion (Clement), who subsequently donated land that formed the nucleus of DeCoursey Park, an attractive family gathering spot on Seventh Avenue Southwest.

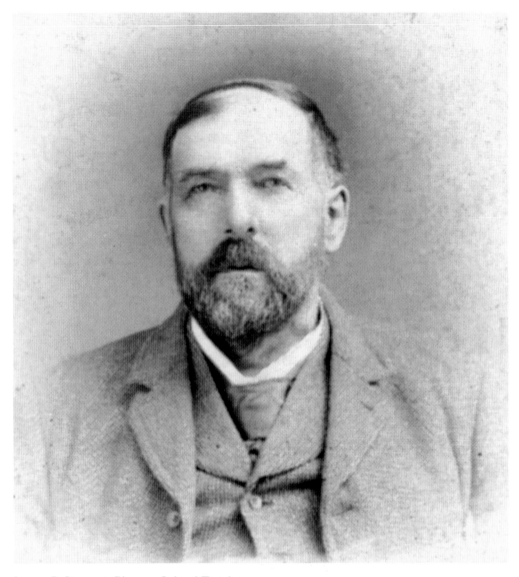

James P. Stewart, Pioneer School Teacher

At age 26, this schoolteacher became the first man to stake a claim on the south side of the Puyallup River after the Indian War. He taught school near Spanaway Lake, was elected Probate Judge of Pierce County, and in 1861, when the Puyallup Valley School District voted to place a schoolhouse on his claim, he was appointed director of the district. When John Meeker bought property next to his, Stewart decided they were a settlement that he named Franklin in honor of his hometown. Later, Ezra Meeker would change the name to Puyallup. Stewart, who had wed Margaret McMillan, a former student, and his three sons bought and developed considerable property, and owned a variety of business interests in Puyallup, Orting, and Buckley. James planted hops and raised raspberries, and his family asserted that he called the meeting that led to the organization of the fair. The Stewart family also donated property to the City of Puyallup. Stewart Avenue pays tribute to this busy pioneer.

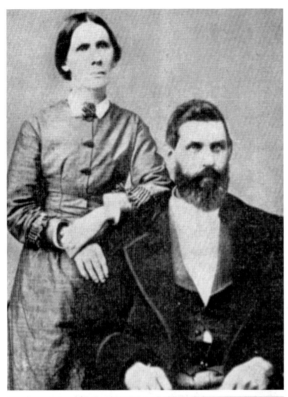

Allen J. and Margaret Miller, Ferry Boat Captain

Allen was born in Queen County, Ireland, and traveled with his New York–born wife, Margaret (Smyth), by boat to reach Steilacoom in 1859. That year, he built a ferryboat to convey teams and lumber across the Puyallup River. After being in the carpentry business for a few years, he cleared a farm in Puyallup and quickly earned his way. He helped organize the Bank of Puyallup, was a member of the first Puyallup City Council, served as a school director, and financed and built the water system in Centralia. (Courtesy of Paul. H. Karshner Memorial Museum.)

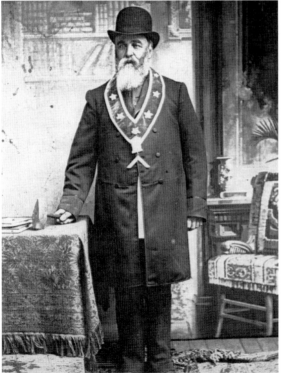

Arthur N. Miller, Early Puyallup Trustee

Arthur N. Miller, Allen's brother, arrived in the valley in 1860 when he was 29 and took up a squatter's claim. He operated a ferry and started a store along the Puyallup River. Unfortunately, a freshet washed everything down the river. In 1888, he was instrumental in establishing the city's incorporation that was subsequently deemed illegal. A mining adventure in British Columbia likewise failed. Perhaps it could be said that with his many disappointments, Arthur's greatest success in life was marrying British-born Alice S. Stevetson, with whom he fathered four children.

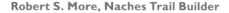

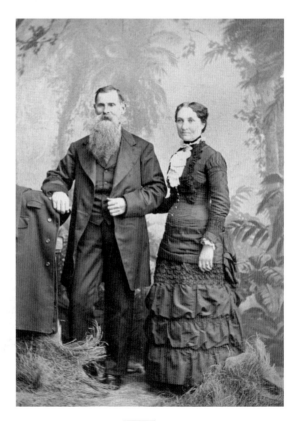

Robert S. More, Naches Trail Builder

Robert and Elizabeth (Smith) More filed a Donation Land Claim along the Puyallup River southwest of Sumner where they built a comfortable home, which hosted the first wedding in Pierce County. Robert joined US Army engineers in building the Naches Trail across the Cascade Mountains for use by wagon trains. The trail crew was camped along the Puyallup River when they heard a loud "Hello" from the other side. That unexpected greeting came from the Longmire Party, the first to venture over the steep and treacherous Naches Pass. (Courtesy of Paul. H. Karshner Memorial Museum.)

Van and Anna Ogle,
Indian War Fighter

Van Ogle was a 28-year-old member of the Longmire Party and later lived with Gov. Isaac Stevens during the Indian uprising. His subsequent memories of the Indian wars put the blame on the Hudson's Bay Company for igniting the rebellion, and unlike Ezra Meeker, Van Ogle had little good to say about Chief Leschi. A shallow place on the Puyallup River bears the name Van Ogle Ford. (Courtesy of Heritage Quest Press, Orting.)

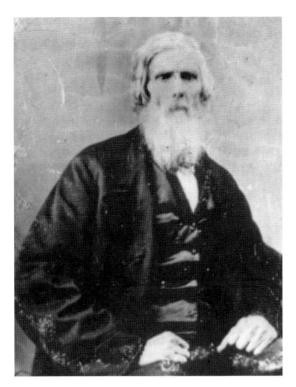

**William Kincaid,
Early Sumner Pioneer**

After losing his wife to illness, this Missouri farmer led, in 1853, a 52-member wagon train over the Oregon Trail and staked his claim in the area that would become Sumner. After the Indian War, Kincaid joined Ezra Meeker in refusing to convict Leschi at his first trial. New settlers used Kincaid's property corners to stake their claims; hence, William is credited with being the founding father of Sumner. His daughter Laura became Sumner's first schoolteacher, and his son John incorporated the town.

**John Kincaid,
Sumner's First Developer**

John at 16 was the oldest son of William Kincaid when the family arrived on the Stuck River. He married Nancy Wright in 1868, and the couple had several children, three of whom died from diphtheria in 1877–1878. In 1883, John platted the town of Sumner on his 160 acres. A strong temperance advocate, in deeding the town, he incorporated a clause prohibiting the sale of whiskey, a ban that lasted until 1951, when Kincaid heirs agreed to remove the clause.

Clara (McCarty) Witt,
First University of Washington Graduate
Clara, daughter of pioneers Jonathan C. McCarty and Ruth Kincaid, was born at Fort Steilacoom in 1858. Educated in Seattle, she became the University of Washington's first graduate, earning her bachelor's of science degree in 1876. A dormitory at the university is named in her honor. Armed with an education, Clara went on to become the first woman to be elected superintendent of schools in Pierce County.

George Ryan,
Sumner's First Mayor
George held a number of firsts in the town he helped to name. In 1873, to entice the Northern Pacific Railroad to run a spur to the town, he personally financed construction of a depot and a year's salary for the stationmaster. After incorporation, he was elected first mayor in 1891. In 1882, he built a skating rink that morphed into a community center used for church services, Whitworth College commencement exercises, and opera performances. His home, known as Ryan House, became Sumner's first library in 1926 and now houses the Sumner Historical Society.

Rev. George Whitworth, College Founder, and Whitworth College, 1895

George graduated from college in 1838 and married Mary Elizabeth Thompson whose forebears were prominent Presbyterian ministers and missionaries. Mission-minded and possessed of wanderlust, George brought his family and sundry relatives over the Oregon Trail, arriving in 1853. In addition to establishing at least 15 Presbyterian churches in the Northwest, George served as a public proponent of higher education. In 1883, he and four colleagues founded a church-based academy in Sumner. In February 1890, the Sumner Academy became Whitworth College, dedicated to giving "both sexes a thorough course of education equal to that of our best Eastern colleges." Ten years later, Whitworth College had outgrown the small community of Sumner and was relocated to Tacoma. In 1914, the school was moved, yet again, to Spokane, where the university continues to fulfill its original mission. George also helped establish and was first president of the Territorial University in Seattle that became the University of Washington. Whitworth died in Seattle in 1907 and was interred at Lakeview Cemetery near his wife. A gravesite monument to his achievements in the state's largest city remains an appropriate reminder of the pioneer known as "the Grand Old Man." (Below, courtesy of Sumner Historical Society.)

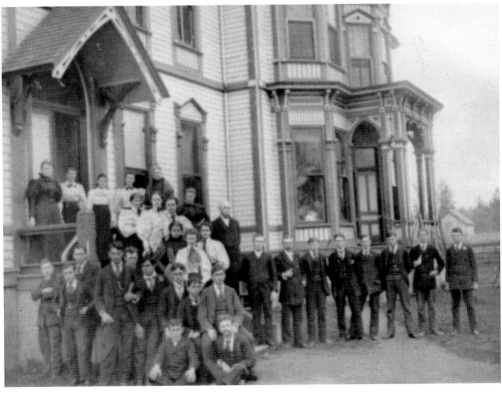

Johnson C. Taylor, Early Orting Mayor
Taylor built a school on his homestead near Electron and later taught school. In 1891, when the state built the Orting Old Soldier's Home for veterans, he lobbied to bring families of veterans to Orting with the proviso that the state help supply them with food. This act, an Orting newspaper reported, "brought to Orting some of the most prominent, active and useful families to figure in the town's history." Taylor served as mayor of Orting a couple of times. (Courtesy of Heritage Quest Press, Orting.)

Margaret Whitesell, Naches Pass Pioneer
William "Henry" and Margaret ventured over the Naches Pass in 1854, staked land claims, and were one of two families who returned to the area following the Indian War. Henry served as the first postmaster of a town that grew up around their property, originally called Carbon, but it was officially renamed Orting when it was incorporated in 1889. Henry and Margaret had 12 children. (Courtesy of Heritage Quest Press, Orting.)

William Harman, Orting Surveyor
William arrived in the valley in 1877. A surveyor by trade, he mapped the small town of Puyallup and moved on to Orting where he owned a successful farm, invested in the First Bank of Orting, served on the school board, and was the supervisor of roads. When Orting was applying to host the Soldier's Home, the town sent William Harman to speak on its behalf. William and his wife, Melissa (Jackson), had two sons, Harry and Icey, who also became prominent citizens of Orting, serving on the town council and becoming mayors. Icey, a trained musician, organized a band. The brothers owned a pharmacy, and Harry later opened a merchandise store in Puyallup before moving to Tacoma. Icey then ran the pharmacy and managed the farm. A major artery in Orting bears the name "Harman Way" in honor of this prominent family. (Courtesy of Wayne and Beth Harman.)

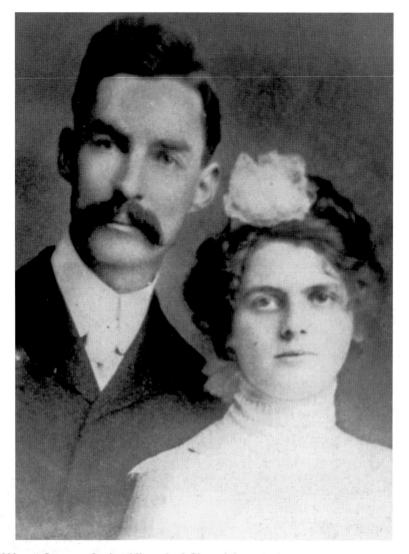

Charles W. van Scoyoc, Orting Historical Chronicler
Charles first came to the Orting valley in 1891 to live with his uncle. After schooling and work in Kansas, he returned in 1909 with his wife, Maisie (Werts), a talented Chautauqua singer and pianist. Charles held many occupations in Orting—teacher, store manager, bank cashier, realtor, notary public, and town clerk, treasurer, and mayor. In addition to serving as lay minister in the Methodist church, Charles became an ardent supporter of the Old Soldier's Home, which recognized his efforts in naming the new dining hall after his son Charles Jr., a lieutenant killed in the Battle of Anzio Beach, Italy, in 1944. Charles Sr. left historical records of the life of Orting from his arrival, a most welcome set of documents for historians. (Courtesy of Heritage Quest Press, Orting.)

The Kupfer Family at Their Farmhouse in 1911

Alois Kupfer and his young family homesteaded on South Hill in 1877. So dense were the forests that a story asserts the family lived on the hill six months before discovering the town in the valley below. They might have starved their first winter were it not for friendly Indians who provided discarded venison after taking the deer hides. Neighbors were few and far between in those early days, but together the Kupfers, Mosolfs, Breckons, Sluthes, and Mankosky families built the first school and the first road down the hill to Puyallup. Today, the Willows Shopping Center resides on land included in the Kupfer homestead. Pictured are, from left to right, (sitting) Fred Kupfer Sr., Alois Kupfer, and Henry Kupfer; (standing) Tony Rauch, Lizzie Kupfer, and Louis Kupfer. (Biography and photograph, courtesy of Jerry Bates.)

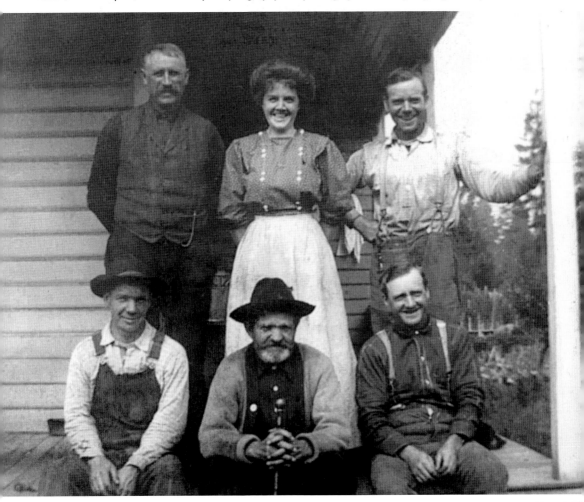

Hop Kiln on George and Theresa Mosolf's Property

George and Theresa (Byrch) Mosolf came to Puyallup in 1879 and purchased 160 acres of land fronting on what is now opposite Wildwood Park. George, born in 1837 in Prussia, first found his way to San Francisco where he met Theresa, a mail-order bride from Austria who turned down the waiting offer and married George instead. The couple arrived with two sons and had six more children; all of them needed to work on the acreage where the family made their way raising hops.

John and Edith Mosolf, South Hill Settlers

John, the oldest Mosolf son, married "Dollie" (Edith Miller) and assumed responsibility for the Mosolf property in 1905. The couple added acreage over time and grew raspberries, strawberries, and a fine cherry orchard. With increasing settlement, another school was needed, and the couple donated one acre and sold another to build the first school on the hill. John's activities extended to being a road-building supervisor; fraternally, he belonged to the Improved Order of Red Men, an affiliation that traces its roots to secret societies formed prior to the Revolutionary War. John and Dollie had four children.

CHAPTER TWO

Developing the Valley Economy

The dense forests of cottonwoods, Douglas fir, and cedar trees slowly yielded to the ax as woodsmen and farmers cleared the land. Memoirs indicate the air was perpetually redolent of fresh sawn wood. Noisy sawmills provided barrel staves, rail ties, and berry and vegetable crates. At one time, the valley had the largest beehive manufacturing plant west of the Mississippi River.

One fortunate day in 1865, Ezra Meeker planted some hop roots given to him by his father, who had obtained them secondhand from England. The hop product, used for making beer, proved so profitable that by 1884, more than 100 farmers had acreage in hops. Not only did the yield benefit the farmers, but also, the crops sustained many families of migrant workers who came to harvest, including Indians. The wealth from hops helped to stabilize the fledgling towns until 1892, when an infestation of hop lice and a depressed market significantly impacted the local industry. Many farmers turned then to berry growing.

With the berries came the need to cultivate, process, and ship them. Growers banded together to create the Puyallup-Sumner Fruitgrower's Association and built canneries that offered rare employment to women. Hispanic workers came to pick the fruit and some remained, establishing roots. When frozen foods entered the markets, entrepreneur Charles Farquhar established a business that thrived for many years.

Bulb growing, mainly of hearty daffodils, began around 1910 and persisted into current times, though with only one remaining field devoted to the bright yellow flower. In its best days, millions of dollars were made harvesting bulbs and blossoms for transshipment throughout the nation.

Retail and service businesses sprang up as the population increased. A few farms, such as the Antone Spooner complex, and several businesses, such as Larson Glass, are today still owned and managed by the later generations of family members of the original owners.

In the period following the displacement of native peoples, another event occurred to blight the settlement record—the peremptory expulsion of Chinese workers in 1887. Citizens, some in public office, forced the evacuation of these immigrants who succumbed to the anti-Chinese sentiment coming from Tacoma.

The Ku Klux Klan (KKK), an anti-Black, anti-union labor, anti-Japanese, pro–white power political terrorist group, roared into mainstream politics in many states in the 1920s, arriving in Washington with strong support from Oregon chapters. In 1929, a KKK parade in Bellingham featured a large float from Puyallup carrying masked, white-robed figures in pointed headdresses. Mass rallies in Sumner and other locations featured cross burnings along with fiery speech.

After Japanese warplanes bombed Pearl Harbor, Hawaii, in December 1941, Pres. Franklin D. Roosevelt ordered people of Japanese origin on the West Coast into internment camps. Hastily built barracks at the Puyallup Fairgrounds, dubbed "Camp Harmony," became temporary home for people of Japanese descent throughout Puget Sound. Japanese farmers, such as the Takeuchi family, had to leave their homes, belongings, and property, and move to the fairgrounds. After several months, families were relocated to permanent camps, except for young men who volunteered to serve their country in uniform.

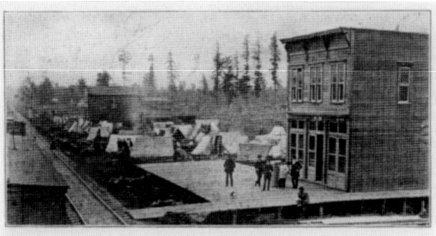

CHINESE HEADQUARTERS, PUYALLUP, 1883

Chinese Store and Lodgings in Puyallup, c. 1880
Chinese immigrant laborers worked on the rerouting of the Puyallup River and worked later for Alexander S. Farquharson, who could be considered Puyallup's first industrialist. Born to a noble family in Scotland, Farquharson opened a sugar barrel factory in Puyallup in 1877. The town's first industrial enterprise produced mountains of staves a day, a scale of effort requiring good workers willing to toil long hours in the elements. When white employees failed him, Farquharson went to Seattle and hired a yard crew of 60 Chinese immigrants who served him well until the anti-Chinese movement, which originated in California, forced him to safely return his laborers to Seattle. Labor was not his only problem. Legal fights with Ezra Meeker over water rights led Farquharson to write the following: "Meeker was broke, and his bondsmen were broke. I was broke, too. Meeker and I had proved to be only a couple of good milk cows for the attorneys." Farquharson sold properties he had acquired in Puyallup in 1893 and engaged in other enterprises in Washington and Alaska, reportedly amassing considerable wealth before his death in 1919.

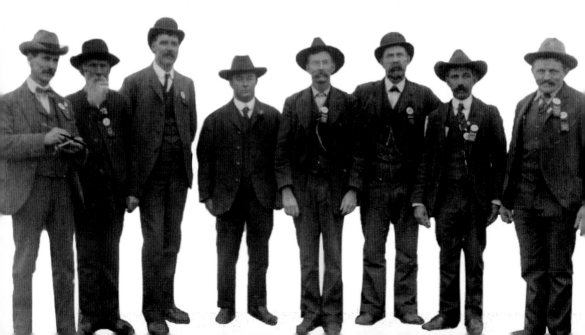

Herman Klaber, Hop Mogul and RMS *Titanic* Casualty

Klaber, born to Austrian Jewish émigrés, managed the Puyallup Hop Warehouse and Supply Company, and by 1902, he owned Meeker's hop barns and many hop fields, seemingly unfazed by the hop industry collapse. In April 1912, after touring hop markets in Europe, he fatally booked a return first-class passage aboard the now infamous RMS *Titanic*. Reports of his failure to survive indicated his personal fortune was then valued at $500,000—nearly $12 million today. (Courtesy of Lewis County Historical Society.)

Early Fair Organizers (OPPOSITE PAGE)

Perry Summerfield grew up playing in Confederate general Robert E. Lee's backyard in Virginia. In 1882, Perry, 31, and his wife, Mary Chilcote of Iowa, came to the valley after farming grain in California for 10 years. Here, the man who would become one of the valley's most productive farmers planted perhaps the first raspberry canes in the area on property leased from James P. Stewart. From those first canes, the berry industry flourished, and Perry homesteaded land north of the present MultiCare Good Samaritan Hospital, growing berries and vegetables, which won many prizes when the annual fair was instituted. In 1899, Perry was appointed superintendent of the Pierce County Poor Farm near Sumner, which he rejuvenated to become a self-sustaining operation and showpiece over the 18 years under his management. He also served on the Puyallup City Council and, in the 1920s, was a constable for a brief period. Mary Summerfield taught art at Whitworth College. Pictured are, from left to right, J.P. Nevins, "Dad" Chamberlain, unidentified, William Paulhamus, Perry Summerfield, George Spurr, unidentified, and Henry Benthien. (Courtesy of Puyallup Public Library.)

Antone Spooner, Patriarch of a Long-Lived Valley Farm
Orphaned at an early age, Antone left Montreal, Canada, at 15 in 1871 for California. In 1881, he and Joseph Wallace, another Canadian, made their way to Puget Sound where they hired an Indian with a canoe to transport them up the Puyallup River to Alderton. There, they bought land, cleared it by hand, and began growing hops. Over time, they also built hop-drying kilns. In order to bale and transport hops, they had to stomp on them, an activity that hop farmers enjoyed doing with each other. When Joe Wallace sent for his family, his beautiful sister accompanied them, and the 35-year-old bachelor Antone fell head over hops. He and Mary Wallace married in 1891 and raised their children in a big home on the property where there were always guests coming and going. Today, the fifth and sixth generations of his family run Spooner Farms, a thriving berry-growing farm with an attractive gift shop and fall fun for the whole family. (Courtesy of Antone Spooner descendants.)

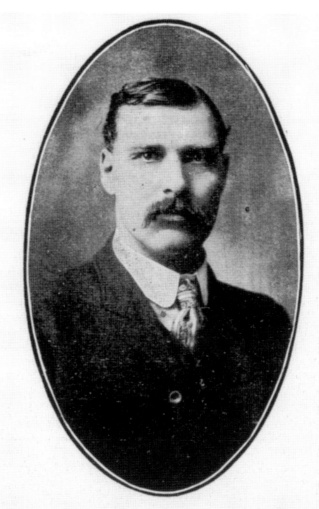

HON. CAREY L. STEWART, STATE SENATOR FROM THE TWENTY-FIFTH DISTRICT.

State Senator Carey L. Stewart, Wealthiest Taxpayer in Puyallup

James P. Stewart's oldest son, Carey, born in 1864, accomplished a great deal in the short 41 years of his life. A reporter once dubbed Carey the "heaviest individual taxpayer" in the valley, owning three large brick business blocks, a number of lots, and considerable acreage within and beyond city limits. In 1900, he was elected to the state senate; six years later, he died after being thrown from his buggy. His wife, Jessie (Jackson), and two sons survived him.

Marvin E. Chase, Truck Gardener
Marvin was probably grateful to his parents, Ichabod and Burissa (Gillam), for giving him a more "normal" name than that borne by his father. In 1887, Marvin and his wife, Margery (Matthews), migrated to Puyallup, where he bought five acres of land, planted a truck garden, and was one of the early berry growers. An industrious man, he helped organize the Puyallup and Sumner Fruit Growers Association and served several years on the Puyallup School Board. The couple had four children, including their son Floyd.

Floyd K. Chase, Canning Manager
Born in 1889 in Puyallup, Floyd became convinced that his future would be in fruit processing; hence, following high school, he began working for the new Hunt's cannery in town, achieving managerial status. He served on the fair board, was on the town council for 10 years, and twice was elected to mayor on a nonpartisan ticket. Floyd married Edna Reinhold, and the couple had two children.

State Senator William D. Cotter, Mega Hop Exporter

In the spring of 1890, William, born on an Iowa farm in 1851, arrived in Puyallup essentially penniless but determined to make a better life for himself and his family. That he did in a matter of only a few years. Initially, Cotter worked for the Northern Pacific Railway until he became a teamster for Ezra Meeker, who liked what he saw in this loyal, hardworking employee. Within a few years, Cotter was made superintendent of Meeker's hop business. Having learned the ins and outs of growing and marketing hops, Cotter allied with Edwin R. Rogers, son of Gov. John R. Rogers, to create a business that traded in hops. By 1903, according to William Prosser, author of the *History of the Puget Sound Country*, Cotter was "probably the largest hop-raiser and exporter in Washington." Prosser asserts that Cotter dealt firsthand with such firms as Guinness in London. Cotter also cultivated berries and was one of the original stockholders in Citizens' State Bank, a director of the Puyallup-Sumner Fruitgrowers' Association, and a member of the fair board. In 1912, he was elected state senator from the 26th Legislative District, but his tenure was short-lived for he died at 58 in 1914. He and his wife, Moselle Morgan, had five children. Townspeople remembered Cotter, not just for his politics or contributions to the wealth of the area, but also for his willingness to give those in need a handout. Indeed, once his empty pockets began to fill, he readily shared the bounty with his neighbors and many mourned his early death.

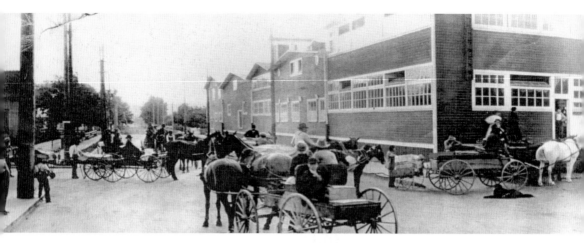

Farmers at the Packing Plant and Berry Farmers Theodore "Ted" and Betty Lou Picha
Ted's parents, Mathias and Gertrude, took up a homestead in 1904, farming the rich valley soil near the mouth of the Puyallup River, west of the town. In 1949, Ted married Betty Lou Goore, daughter of immigrant Norwegian parents, and they spent their lives on the farm. They had five children, including sons Daniel and Russell, both local teachers, who also continue to produce fresh fruit. Locating and keeping qualified pickers remained a difficult task for Ted and Betty Lou until the mid-1970s, when refugees from Vietnam began arriving. Dressed in their traditional clothing and conical hats, the Vietnamese quickly grasped the skill needed to pick the delicate fruits without endangering the canes, plants, or fruit and became a very reliable labor source for area farmers. Ted introduced the tayberry to the area in 1983, a cross between a raspberry and a blackberry. As the local packing plants closed, the market for processing valley fruits and vegetables declined, but the Picha legacy lives on through the delicious fresh berries and plump pumpkins that are highly prized throughout the county. (Courtesy of the Picha family.)

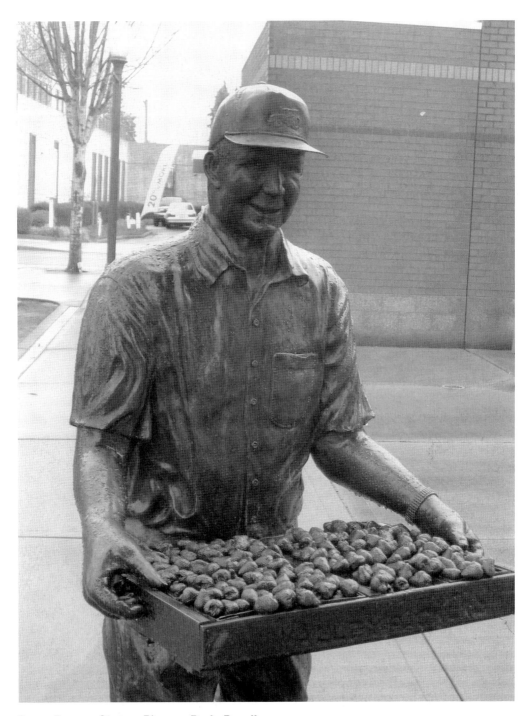

Berry Farmer Statue, Pioneer Park, Puyallup
When the Puyallup Heritage Art Foundation was looking for a model for a statue of a berry farmer Diane Kienholz, the president chose Ted Picha, noting the following: "Everyone said Ted Picha. It's so in his blood." Artist Paul Michaels modeled the realistic bronze statue, which stands in front of the pavilion in Pioneer Park.

Charles Orton, Gentleman Farmer

Charles was a refined, college-educated, well-spoken man at ease with farmhands, businessmen, and social leaders. He built a showplace home on his farm near Sumner and started raising bulbs in 1914. In 1922, he married Virginia Carter Keating MacCraig, a Southern belle from an aristocratic family who held spring parties to celebrate the fields of daffodils that surrounded their beautifully landscaped property. Charles held many official titles, including president of the Washington State University (WSU) Board of Regents. Orton Hall at WSU honors Charles Orton's dedication to the university.

Edward "Ed" Orton, Bulb Grower

Edward, one of Charles's Orton's brothers, married Grace Parker, and the couple raised daffodil bulbs and other products. Ed liked working alongside his laborers. Grandson Fred Orton, a Puyallup High School teacher, recalls that his grandfather sold land to Japanese laborers, and when the Japanese were interned in World War II, Ed kept farming their land and maintaining their homes so that their property was available to them when they were freed. Today, the fifth generation of Ortons is making its way in the valley. (Courtesy of Fred Orton.)

Simon van Lierop, Daffodil Grower

Simon van Lierop, born in 1900 in Voorhout, Holland, grew up one of 14 children; his family managed a bulb farm in the Netherlands for many generations. When he was 20, Simon and three of his brothers left for America. In 1929, when Simon was working in Chicago, he learned that Ed Orton was looking for an experienced bulb raiser, so Simon jumped on a train, came out, liked the area, and sent for his fiancée, Beatrice Johnson, a farm girl. They married on her first afternoon in Tacoma, and the pair began selling flowers from Ed's farm. Simon's bulb knowledge led to the importation of Dutch bulbs and, ultimately, the purchase of acreage south of town where the couple raised bulbs and opened a garden store. At the time of his death in 1962, Simon was a director of the Puget Sound Bulb Growers' Association and a member of two local service clubs. Beatrice became community supporter extraordinary, honored in 1974 as the Puyallup Business and Professional Women's Club "Woman of Achievement." She and her son Neil operated their business until her death in 1975. Neil and his family continued to grow bulbs and sell flowers, expanding their garden store and supporting the annual Puyallup Valley Daffodil Festival. Those days have ended, though, because the firm could not compete with the inexpensive South American flowers that appeared in the large supermarkets at a time when the economy was in slump. Neil's daughters and their mother opened a floral store in Sumner that intends to keep alive the memory of the splendid yellow flowers. (Courtesy of Neil van Lierop.)

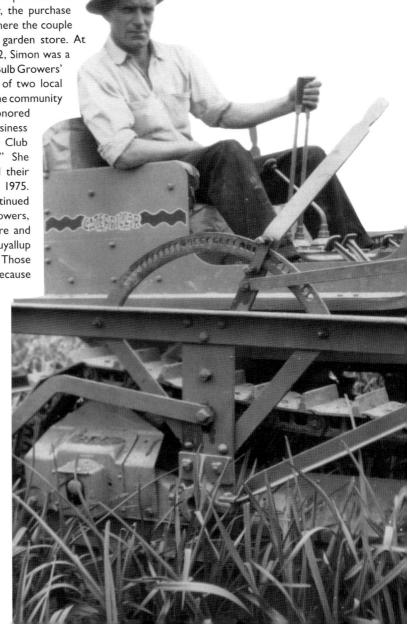

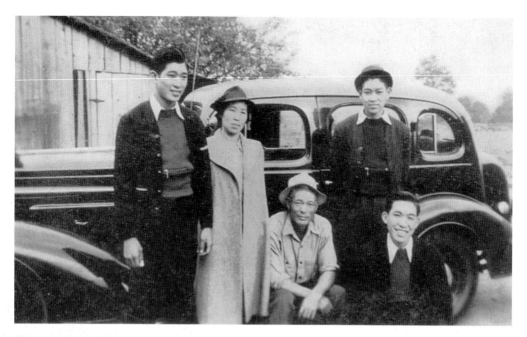

Shigeo, Mistsui, Yoshitsugu, Yukio, and Saburo (Robert) Takeuchi, 1939
Yoshitsu came to Washington in 1907, farmed for 10 years, and returned to Japan to marry Mitsui and bring her to America. In 1932, the family of five moved to Puyallup and settled on a berry farm. Yukio was a senior in high school when the Takeuchis were ordered into Camp Harmony at the Puyallup Fairgrounds. When it came time for the Puyallup High School class of 1942 to graduate, Supt. Paul Hanawalt arranged with federal authorities to escort seniors Yukio Takeuchi and Rosie Takemura (editor of the Puyallup High School annual) to the commencement ceremony. On the way back to Camp Harmony, Hanawalt stopped by Martin's Confectionery to buy ice cream for the new graduates. When the family was relocated to Camp Minidoka, Idaho, all three boys enlisted to serve their country in World War II. Shigeo fought in the Pacific Theater, and Yukio and Robert served in the highly decorated, all-Japanese 442nd US Army Infantry Regiment. Following the war, the family returned to the Seattle area. (Courtesy of Bryan Takeuchi.)

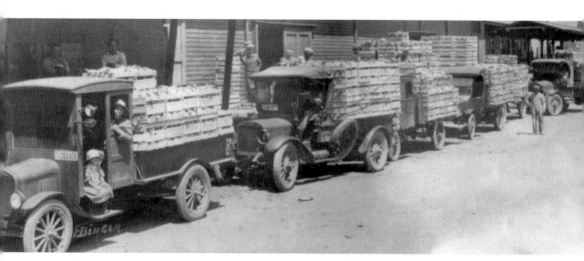

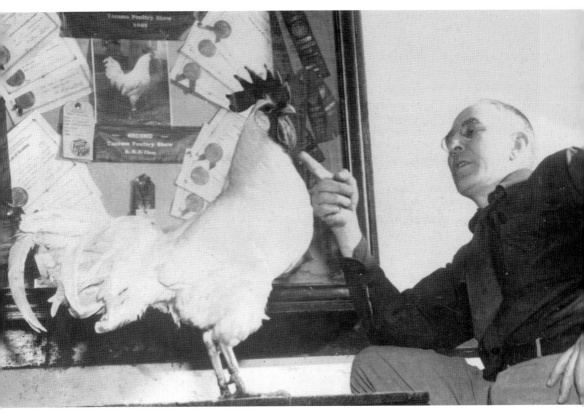

Percy Rowley, Poultry Producer and Exporter
Not all significant exports from the valley emerged from the soil; rather, some were hatched—by the thousands. George and Hermie Shoup, who taught at the Western Washington Experimental Station in the early 1900s, revolutionized egg laying by introducing lighting and other measures. Percy, whose family had emigrated from Canada, took a course from the Shoups and founded Rowley's Poultry Farm. He trap nested primarily New Hampshire Reds that he shipped as eggs or pullets to places as unlikely as Hong Kong, and even to the Soviet Union during the darkest days of the Cold War. In the early 1950s, Percy was selected by the United Nations to accompany three planeloads of eggs to South Korea to rebuild their poultry farms. In 1925, Percy had married Cecelia "Cece" Gross, whose family had followed the Rowleys to the valley from Wetaskiwin, Alberta, Canada. The couple had three daughters, became world travelers, and established a student exchange program between the Puyallup Kiwanis Club and that of Wetaskiwin. Cecilia died in 1989, and Percy passed away in 2000 at age 98, a gardener to the end. The Washington State Fair now owns the farm property on the corner of Fifth Street and Fifteenth Avenue Southwest. (Courtesy of Celia Vincent.)

Japanese Farmers Waiting to Unload Their Trucks, c. 1940 (OPPOSITE PAGE)
Only a few Japanese American families came back to the valley after the war. Elders were either too old to farm or their property was lost, and the second generation mainly chose to work in other professions at a time when agriculture was yielding to development and the workforce was changing.

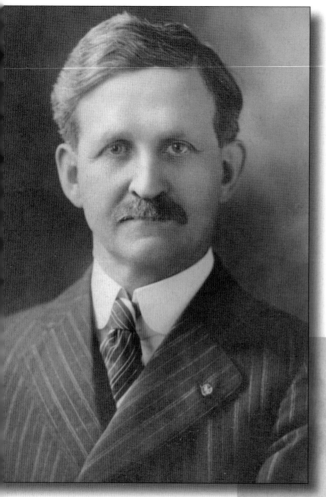

Harry G. Rowland, Early Puyallup Lawyer

A transplant from Pennsylvania, Harry initially practiced law in Puyallup. In addition to private litigation, he acted as city attorney for several years, earning a reputation for careful preparation of his cases. In 1903, while maintaining a Puyallup residence, he and his brother Dixon formed a law office in Tacoma where Harry rapidly became a well-respected attorney, representing Pierce County in litigation involving, for example, the validity of taxing public service corporations.

Nettie Hallenbeck, Superb Cook

Nettie was, by all accounts, a very fine cook who operated a restaurant in the Central Hotel on the southeast corner of Main and Meridian Streets. In 1885, the Hallenbeck family bought the building, and for the ensuing 26 years, Charlie and Nettie managed the property. Each noon, when she had prepared the ample lunch, she would bustle out the front door and ring a big school bell to alert her patrons that it was time to come and dine.

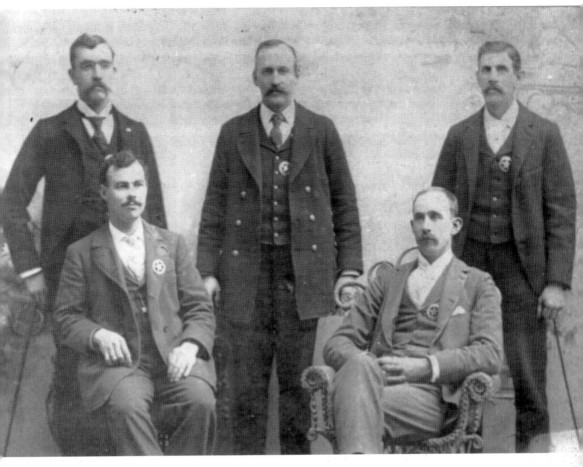

Puyallup Merchant Policemen
Charles Hood loved to tinker. A tinner by trade, Charles came to Puyallup in 1890 and, a year later, partnered with Ezra Meeker and three others to establish the Puyallup Valley Hardware Company. Seven years later, Charles bought out his partners and continued the lucrative business under his name. Hood's Hardware soon became a leading store in this part of the state, carrying all manner of farming and household equipment, tools, and appliances. Putting his training to good use, Charles invented a number of timesaving machines, including a hop sprayer and a raised arch mower that he gave to state road crews for mowing along highways. In 1897, he married Iowa transplant Aida M. Reid, an early schoolteacher at the old Central School. She was also secretary of the Pierce County Anti-Tuberculosis League and a member of the state anti-tuberculosis board. The couple lost much of their wealth during the Great Depression because Charles insisted on paying all of his debts without collecting on those due him. Pictured are, from left to right, (standing) Willie Whealer, Charles Mathias, and William A. Hall; (sitting) George Berry and Charles Hood—a generous inventor.

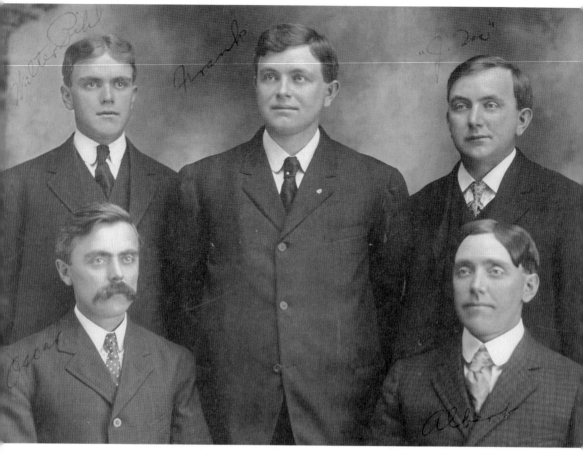

Pihl Brothers

These handsome young men and four siblings accompanied their Swedish parents, Carl and Sophia Pihl, to the area by train in 1888. Carl bought five acres on Seventh Street Northwest and worked as a carpenter on many buildings in town. The boys helped their parents develop their property, producing fruit, vegetables, meat, eggs, and milk. What the family did not need, they sold. Oscar and John liked retailing so much that they established a grocery store and, in 1911, bought the Central Hotel from Nettie Hallenbeck, razed it, and erected a large store on the premises. Pihl Brothers Grocery sold foodstuffs, feed, and seed. The grocery also served as the communications center for the town fire department. When calls were phoned into "Main 61" at the store, one of the partners would run down to the old firehouse and ring the bell to summon other volunteers. Oscar bought out his brother and continued to manage the business until 1926. Frank Pihl opened Cash Market, the first meat market on the corner of Stewart and Meridian, and later established two meat markets in Tacoma. The children prospered, and the Pihl family remained influential in the valley, working in various enterprises and supporting the civic and social life of the area. Pictured are, from left to right, (first row) Oscar and Albert; (second row) Walter, Frank, and John.

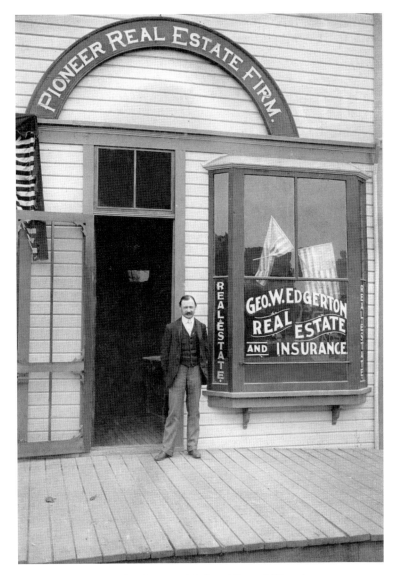

George W. Edgerton, Realtor, Banker, and School Board Director
George, fourth child in a family of 12, could have accepted his father's usual gift to his sons who reached manhood—a team of horses. But George asked to continue his education instead, preferring the classroom to transportation. Upon graduating valedictorian from a teaching academy in Holton, Kansas, he taught school before the West captured his fancy. In 1891, he brought his bride, Lillian Meador, to Puyallup where he entered into the real estate business and managed to sign the town's legal incorporation papers. George held many public offices, such as school board director for 24 years, president of Citizen's State Bank from 1911 to 1929, financier of Woodbine Cemetery, and postmaster under Republican presidencies. His childhood upbringing gave him a healthy respect for farmers; at one stage, he bought 2,500 chickens to support the fledgling poultry association, and he always grew a "weedless garden" on his property on west Pioneer Avenue. George and Lillian had five children who grew up to be active in the Methodist church. Choosing college over horses proved a mighty good decision for a man who enjoyed considerable clout in his 60 years in the valley. (Courtesy of Paul H. Karshner Memorial Museum.)

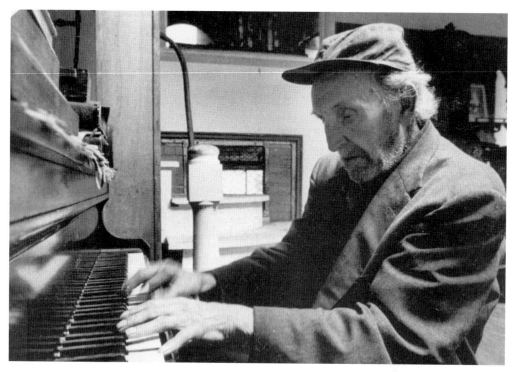

Frank Shaw, Road Engineer

Frank could still produce a good tune on an old family piano in his 90s. His father, Christian Shaw, brought his wife and six children from Colorado by horse and buggy in 1901, and they settled on heavily timbered property south of town. It took four years to clear the 15 acres that produced berries, fruit from an orchard, and vegetable products. In 1920, Chris and Frank Shaw and Guy Clifford completed the road leading to Pioneer Avenue from their property. At the insistence of the Washington State road commissioner, the professionally prepared byway was officially recorded as Shaw Road, a name it carries to this day.

John B. "Jack" Donley, Plumber

During World War I, Jack maintained aircraft as a US Naval Reserve mechanic in San Diego where he met his future wife, Lulu Prouty. After the war, the couple returned to Puyallup where they had two children, and Jack established himself as a master plumber, responsible for the plumbing and heating of a number of schools, businesses, and homes. According to local lore, it was Jack who suggested that floats incorporating flowers be paraded at the first daffodil festival, a commendation that has delighted participants and onlookers for decades. Jack was active in the Shriners Corinthian Lodge and grew handsome beards for Meeker Days' celebrations.

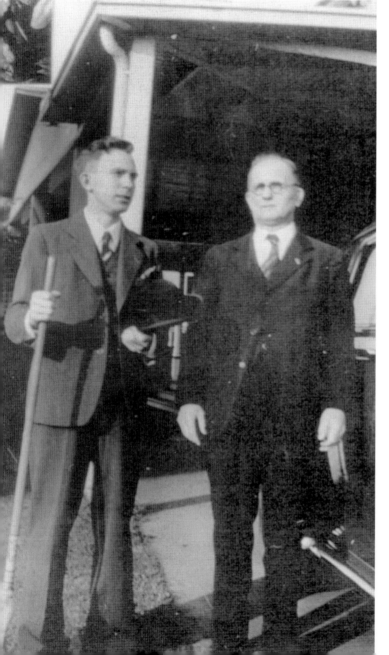

Vernon Hill, World War II Hero, and Ernest N. Hill, Mortician

Ernest, a farm boy from Michigan, served his country in the Spanish-American War where he fought in the Philippines. In 1902, the 31-year-old apprenticed with a mortician in Portland before moving to Tacoma where he obtained Washington State Anatomy, Sanitary Science, and Embalming License No. 107 in 1905. After marrying Mabel Richards the next year, the couple moved to Puyallup and started their mortuary business, now in its 108th year. Ever the patriot, when Ernest discovered he was too old to enlist in World War I, he promptly organized and commanded an infantry company called the Puyallup Home Guard. The guard trained soldiers for the US Army and regularly drilled in Pioneer Park. Ernest and Mabel both held memberships in numerous organizations and routinely participated in activities for the youth of the area. Pictured with Ernest is son Vernon Hill, one of five children. He was a hero of World War II, helping downed pilots escape the Japanese in China.

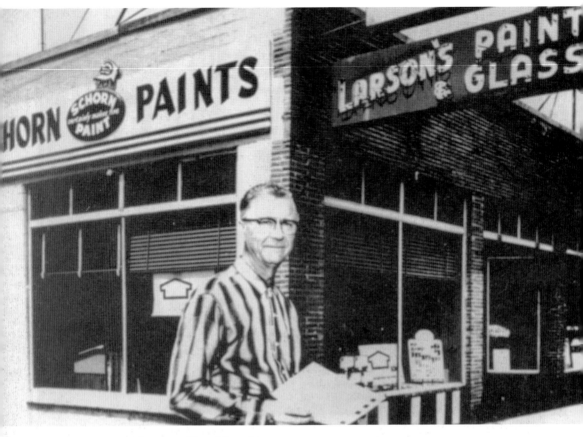

Reuben "Rube" Larson, Glass Manufacturer

Reuben's parents gathered their courage and emigrated from Norway in their teens. In 1902, son "Rube" was born in Minnesota, which he left at the age of 19 to move to Puyallup. Here, he obtained a job in a paint store where he met Josephine Snider; they married in 1927. Nineteen years later, Reuben opened Larson's Paint and Glass, a company that has been providing windows and other glass products for homes, businesses, and automobiles for 67 years. The couple had two children, and in 1953, when he was 20, son Donovan "Don" began working in the business. In 1972, Don assumed ownership and moved Larson Glass to its current location, an 1891 brick building on Stewart Avenue that had housed Boush Moving Company, among others. Rube, who died in 1974, was well known for telling stories, enjoying his grandkids, supporting the Elks, and fishing whenever he had the opportunity. Don's wife, Mary Ann (Pruett), and their sons, Jerry and Doug, all work in the business. Community commitment remains high on the Larson priority list. Don and Mary Ann still attend Peace Lutheran where his parents were members, and Jerry is president of the fair board. (Courtesy of Don Larson.)

**Walter C. Stevenson,
Lumber Inspector**
Walter was 17 when he came West to join his brothers, including George, who had partnered with William Patterson to operate a sawmill. Once the steam donkey engine became available, the brothers bought one, purchased land near Puyallup, and began milling shingles—20 million of the pungent wood pieces. Walter had married Lucy Wescott from Orting, and they had six children. He bought one of the first cars in town, and the family would chug up to Mount Rainier and camp, adventures that took days in the early 1900s. After selling his interests, Walter became a lumber inspector at various ports.

William E. Patterson, Sawmill Owner
William was adept with a variety of musical instruments, playing in local bands and entertaining his family. He and his wife, Achsah (Lafferty), were living in Des Moines, Iowa, when they decided to join his sisters who were both living in Puyallup. On arrival, William began working with George Stevenson, a brother-in-law who owned a sawmill. William, who had a reputation for treating his workers well, bought the mill and was the first to use a tractor for hauling the fresh-cut lumber.

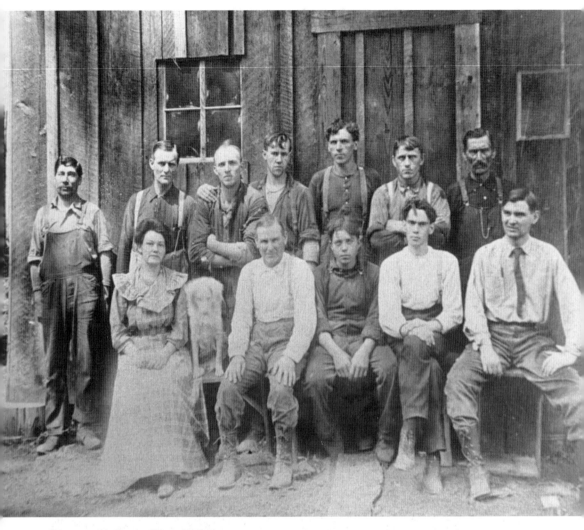

Thomas H. Brew, Sawmill Owner

These days, Thomas Brew might be investigated for insurance fraud, but there are no indications that suspicion arose as one after another—four in all—of his local sawmills went up in flames in the years 1920, 1935, 1942, and 1968. The last fire occurred 17 years after his death. Each fire destroyed his facility, and the first fire also destroyed several homes, but Brew rebuilt in different locations, each mill contributing to the local building industry and economy in general. Brew, born on the Isle of Man, was married to New York–born lass, Sarah Carpenter. She lived to be 94 and Thomas nearly 100. Pictured are, from left to right, (first row) Sarah Brew, Thomas Brew, unidentified, Marian Brew, and Harold Brew; (second row) unidentified mill workers.

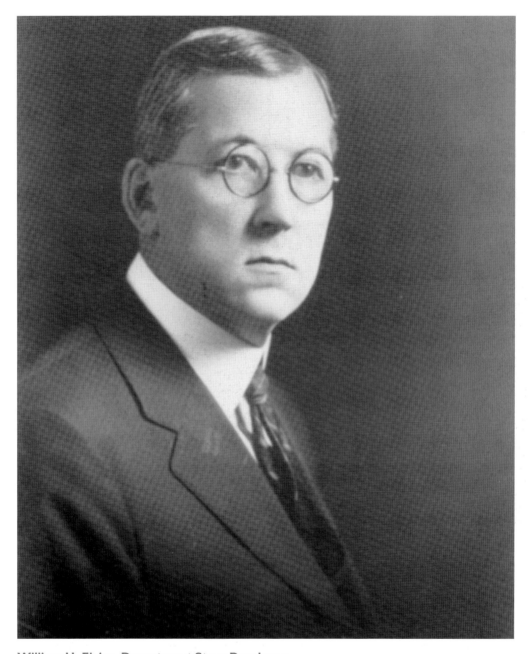

William H. Elvins, Department Store Developer
This young Canadian opened a shoe store on Meridian and Main Streets in 1894. Through ups and downs the business grew, and by 1906, Elvins built a larger store whose name is still visible on the facade of 108 North Meridian Street. Son Larry expanded the business in 1936, and by 1948, he and his wife had moved the store to the Karshner Building. Their son Dennis took over in 1964, moved the store to the new Hi Ho Shopping Center north of town, and ultimately opened four additional stores, the chain becoming the largest family-owned department store operation in the state. The stores were subsequently sold when national chains moved in. Denny retains a thriving real estate business in Puyallup. (Courtesy of Puyallup Public Library.)

Abram S. Hall and his Wife, Lillie M. (Wilcox)
The couple was living in Michigan in 1893 when they decided to visit the much-touted Chicago World's Fair. Among the many elaborate pavilions, they found themselves drawn to a large log building filled with exhibits from the new state of Washington. They promptly moved to Olympia and, in 1903, to Puyallup. Abram bought property, successfully raised berries, and operated other enterprises. For 18 years, Lillian and her daughters owned and managed a millinery store, supplying local ladies with fashionable hats. She also helped bring the Carnegie Library to town. In 1942, the Halls used their influence to have a World War II Liberty Ship named for Ezra Meeker. The tanker made 78 ports of call before being scrapped in 1969.

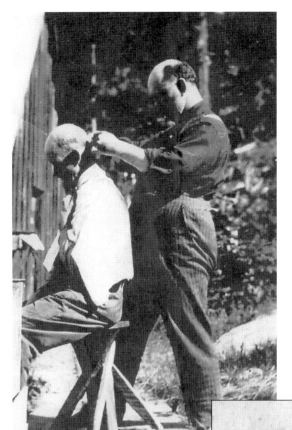

Marcus Porter, Common Man's Attorney

After receiving his law degree from the University of Washington, Marcus Porter and his wife, Mantie (Sanford), came to Puyallup where Marcus hung his shingle as the second lawyer in town. His practice did well, and he acted for clients from Puyallup to Orting. A year after Mantie was killed by an electric train on the tracks behind their home, Porter married his secretary, Alma Fields. Marcus and Alma's son Mark was killed in World War II (see page 83). Porter appealed to all seekers of justice. Questioned by his daughter on hearing her father use the word "ain't" in court, he told her that it had been an "ain't" jury, all from rural areas. Marcus, shown here in the Klondike being shorn by Robert Montgomery (see page 70) like Ezra Meeker and many others, sought to strike it rich during the gold rush in the Yukon. Porter and Montgomery bought claims that they later visited, as depicted in this photograph. There is little evidence that any valley people succeeded in finding gold.

Per Truedson, Druggist

Per, born in Sweden, was 26 when he moved to Puyallup in 1889 and took a job in a drugstore that was destroyed a year later in the great fire that wiped out many commercial buildings. The next year, Per and his brother opened a drugstore in the new Spinning block at Meridian and Pioneer Streets. The business quickly became the hub of the downtown area. Citizen's State Bank was launched in a backroom, and for 48 years, Per was its secretary. He also helped organize Woodbine Cemetery and led the effort to raze the Park Hotel that had never been completed and was causing safety concerns. Truedson sold his store to Streator Beall, became a pharmacist in Tacoma, and died in 1949.

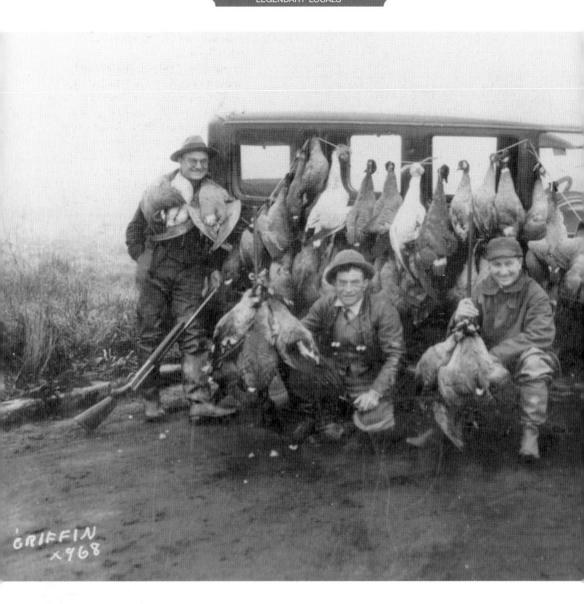

Beall's in the 1940s (OPPOSITE PAGE)

In the 1940s, Walter and Tress Dassel purchased Beall's store, and Larry Norris bought it in the 1960s. Dr. Mark Norris, a third-generation pharmacist, took over Beall's store in 1991 and, in 2004, revamped the business and opened it as Beall's Compounding Pharmacy. As Mark likes to put it, "we're back to the future, practicing pharmacy like my grandfather did"—but making full use of state-of-the-art technology and formularies. Pictured are, from left to right, Larry Norris, Kenneth Lamoine, unidentified, Walt Dassel, Mary ?, Delores Harlow, and unidentified. (Courtesy of Mark Norris.)

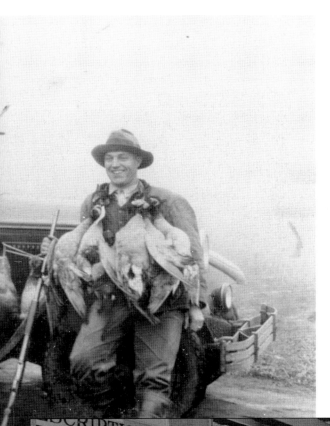

Streator Beall, Pharmacist, with Friends

Streator Beall very likely acquired his unusual name from his father, whose family lived in Streator, Illinois. In 1912, Beall bought Valley Drugstore, established in the 1890s. Rexall Drugs was in its first decade at the time, and Beall bought a franchise, naming his store Beall's Rexall Drugs. Note that Beall enjoyed a little hunting with his friends. He also helped found the Puyallup Kiwanis Club. Pictured are, from left to right, Mike Barovic, Streator Beall, Jack Donley, and Harry Bader. (Courtesy of Don Barovic.)

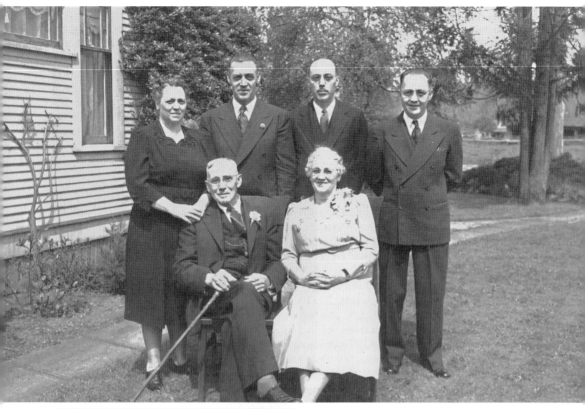

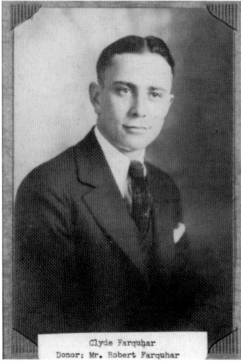

Clyde Farquhar
Donor: Mr. Robert Farquhar

Clyde D. Farquhar, Frozen Food Specialist

Clyde was born in 1895, the son of a blacksmith. He worked in the berry fields in the valley through high school and then in the local canneries. After serving in World War I, Clyde learned all he could about processing fruit and vegetables and became a manager for the Washington Packers, Inc. Once frozen food production began in the mid-1920s, Clyde took on marketing duties, traveling throughout the world to sell the valley's processed products. In the late 1930s, Clyde entered into business with a Mr. Kelley, and soon, Kelley, Farquhar and Company were selling frozen foods throughout the world. During World War II and again during the Korean War, the company ramped up production to meet military needs, remaining in business after hostilities when many companies went under. In 1958, Clyde became sole owner of the company, and in 1970, he was elected to the national "Distinguished Order of Zerocrats," an honor by contemporaries in the frozen food industry. (Courtesy of Puyallup Public Library.)

Coe Family of Orting (OPPOSITE PAGE)

Charles and Margaret came to Orting in 1889 and bought an existing store called Pulley and Higgins. Charles later invested in a sawmill and served on the Orting Town Council twice. He is also remembered for his horse Dexter, who helped haul wood and other products. It seems Dexter had a not-so-secret drinking problem—he loved beer. Somehow the animal had learned how to pry off the top of a glass bottle and would guzzle the contents, often becoming a little tipsy in the process. He also liked a good plug of tobacco when one was offered. Burton served as town treasurer, fire chief, and mayor. The family is shown here on the occasion of the Coes' 50th wedding anniversary. Pictured are, from left to right, (standing) Edith, Burton, Donald, and Kenneth Coe; (sitting) Charles and Maude Coe. (Courtesy of Heritage Quest Press, Orting.)

Robert F. Boush and Son, Moving and Storage Entrepreneur

When 35-year-old R.F. Boush started hauling berries from local farms to area canneries with his horse and wagon in 1919, he likely had no idea that Boush Moving and Storage, Inc., would one day be among the longest surviving businesses in the valley. But that is what this hardworking Canadian, whose father had emigrated from Austria, begat. In the mid-1920s, R.F. purchased property on Fourth Street, built a home, married Johanna Pendle, bought a Ford truck, and started transporting wood and coal. Eventually, he moved the business from the warehouse on Stewart Street to Fourth Street where it remains. R.F. managed the firm until he was 75, relying on good customer relations and word of mouth to keep the company growing, tenets that have continued. Carl Boush, Robert's grandson, and his cousin J.K. Boush now run the company, overseeing 15 employees who operate a 10-truck fleet. The company's affiliation with the international Atlas Moving Company and their solid reputation for careful handling of home and office moves keep the business thriving. R.F. loved playing Santa Claus for the fire department, and he encouraged the use of the fleet for community purposes. Hence, that Boush truck seen on the street may not be delivering furniture or personal goods but items for the local food bank. (Courtesy of Carl Boush.)

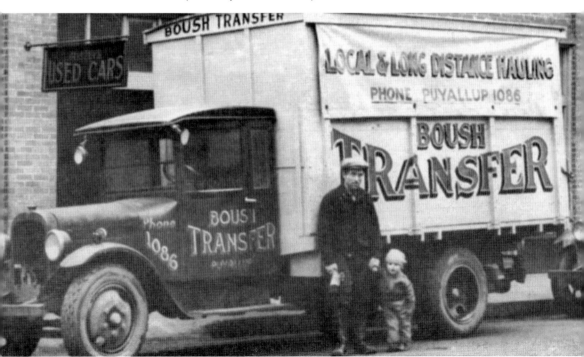

Russell "Barney" Absher, Construction Visionary

Barney, born in Kentucky, put his "Mr. Fix It" skills to good use in 1940 when he started remodeling homes in the valley. From those modest beginnings, Absher Construction has grown into a multibillion-dollar business, erecting mainly large, public-use structures, such as schools and military buildings, in several states with a few abroad. Barney's sons Thomas Sr. and James and partner Clark Helle Sr. took over in the 1950s, and the third generation replaced them in the late 1990s. Today, the Absher family again solely owns the company, and the fourth generation is making its mark, employing new technology to construct the most efficient, safe, and environmentally friendly buildings possible. "Doing Things Right and Doing Right Things" is the company's motto, and it not only permeates the business but also the philanthropy for which the family is noted. Abshers have served on the fair board for decades and have been major donors to St. Francis House and Cascade Christian Schools; they annually offer college scholarships to high school graduates. (Courtesy of Russell Absher descendants.)

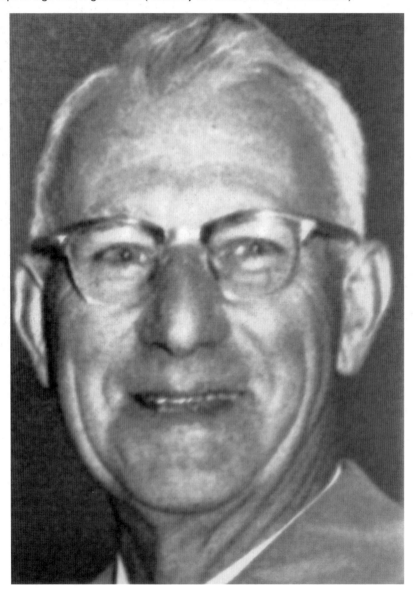

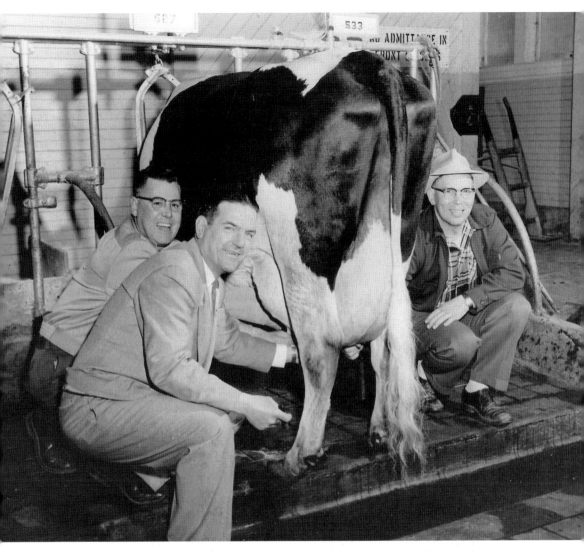

Newell Hunt, Furniture Store Owner

Newell Hunt arrived in Puyallup in 1916 and began working at Puyallup Furniture, owned by Lathe Larson. When Lathe's sons returned from World War II and needed work, Newell decided to start his own furniture business. In 1946, he opened a store featuring furniture and appliances in a 16,000-square-foot building on West Stewart Street. More than 3,000 people, many in their Sunday best, attended the grand opening of the store on May 22, 1947. In the 1960s, son Warren and his wife, Dorothy, joined the sales team and eventually took over the business, which now resides in the same location but with a 30,000-square-foot store and warehouse. Arla Cuddie bought the business in 2002 but maintained the name: Newell Hunt Furniture. Newell, a dapper dresser who loved music and the arts, was a faithful member of the Kiwanis Club, and he and his wife, Alice, sang in the choir at the Methodist church among many other community activities, such as milking cows for fair photographs. Pictured from left to right are Truman Frye, Hunt, and Murrey Murdock. (Courtesy of Kiwanis Club of Puyallup.)

Johnson Jewelers Family
At age 18, John G. emigrated from Iceland and, in 1898, established a jewelry business in Mountain, North Dakota. While attending a Shriners convention in Seattle, Johnson went touring and decided Puyallup would be a good place to relocate the family business. In 1936, he established the first store downtown. Since that time the business has relocated three times, most recently, in 2002, back to a downtown location on Meridian Street. Today, this attractive store, fronted by a stately vintage street clock, is owned and managed by fourth-generation family members. John G.'s great-granddaughters Jodi and Amy receive rave reviews for their customer service, uniquely designed jewelry, and home decorative items. Pictured are, from left to right, Fred Wepfer, Julie Johnson, Walt Johnson, Vivian Wepfer, David Johnson, Robert Johnson, John G. Johnson, and Gladys Johnson in 1948. (Courtesy of the Johnson family.)

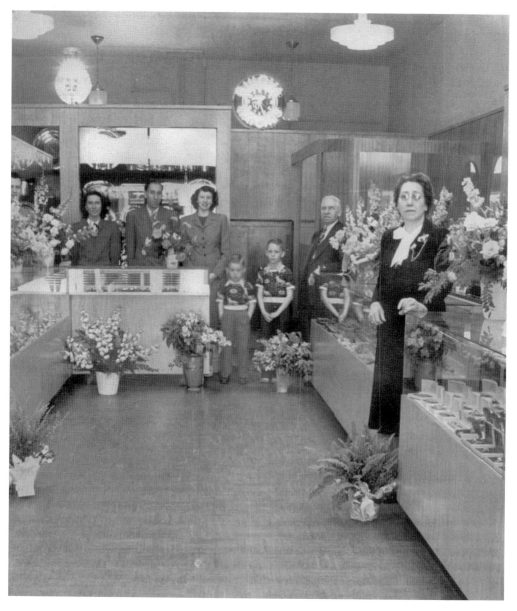

Jerry Korum, Philanthropic Car Dealer
Jerry Korum is a second-generation Puyallup car dealer whose father, Melvin, opened a Dodge-Plymouth dealership in 1956. At the age of 20, Jerry started working for his father, and at 25, Jerry owned a Ford dealership, the youngest Ford dealer in the nation at that time. "Don't do business alone" became Jerry's motto, and to this day, the phrase he and other dealers established decades ago—"Cars cost less in Puyallup"—resonates throughout the nation. In 2013, the Korum Automotive Group includes franchises for Ford, Lincoln, Hyundai, and Mitsubishi, and Jerry also owns a real estate and construction business. Jerry and his wife, Germaine, have been incredibly generous to the community. Their faith-based lives have led them to establish the Korum for Kids Foundation, administered by their daughter Sophia, to promote the welfare of youngsters. Among many organizations that have benefited from Jerry and Germaine's generosity is the Mel Korum YMCA, built in 2000 that honors Jerry's father. A member of the fair board since 2005, Jerry has championed the effort to rename the Puyallup Fair the Washington State Fair, thereby ensuring more regional and national recognition for this emblematic community event. (Courtesy of Jerry Korum.)

Brian McLendon, Hardware Store Manager

Brian, shown here in his youth, is a justifiably proud third-generation hardware store owner, managing the Sumner McLendon Hardware store. Brian's grandfather Moses "Pop" McLendon launched a horse-and-wagon door-to-door secondhand business in Renton in the late 1920s that led to the establishment of a brick and mortar store. In 1971, the family opened a second store in Sumner where Brian began learning the trade from the bottom up. Six other stores followed, including a large complex on Canyon Road and a recent store in Tacoma. Stressing customer service and a wide selection of goods, Brian caters to his clientele by offering such community events as "Ladies' Night," featuring "pink products," and Kids' Clinics, which teach youth to build things. (Courtesy of Brian McLendon.)

Paul G. and Diane Williamson, Nursery Owners

Paul and Diane (Brunhoff) Williamson own one of the loveliest settings in the valley. Their eight-acre plot on the Orting Highway hosts Todd's Nursery and Landscaping, a business established by the Todd family in University Place decades before it was moved to the old Jonas farm, its present site. Paul bought the property and business in 1987 and has become the man to go to for landscape design and plantings. Diane runs the extensive indoor-outdoor nursery, advising homeowners on what plants would thrive well in their gardens. With development rapidly encroaching from all sides, the Williamsons are determined their piece of paradise will remain a place where employees, clients, and the special education kids they host are able to experience the panoply of flora in the valley.

CHAPTER THREE

Meeting Civic Needs

Each municipality established town councils that annexed more land as the needs arose. John Kincaid essentially developed Sumner from his own land claim. Local governments also cooperated with each other to provide transportation links among their communities and to facilitate trade with Seattle and Tacoma.

Early settlers had to hold many positions to keep the towns going. Postmasters were assigned according to whatever political party held the White House. Rough-and-tumble city politics have prevailed from settlement, as have disputes over land use. Ezra Meeker and James P. Stewart engaged in a rivalry that is still under discussion in Puyallup.

When the Washington State Legislature was established after statehood in 1889, elections sent several men to Olympia who retained their offices for many years. Washington's third governor came from Puyallup, and so have state superintendents of public instruction "Buster" Brouillet and Judith Billings, the third woman elected to the position.

Once technology permitted, alarms were installed to warn residents of a lahar that could send tons of Mount Rainier's crumbling facade rumbling down into the valley. Sam Colorossi, former mayor of Orting, spends his days trying to secure funding for a foot bridge to provide a means of escape should lava and debris be threatening to bury the town.

In 1890, one month after incorporation, Puyallup suffered a devastating fire that virtually wiped out the downtown cluster of small wooden structures. Soon, Puyallup Hose Company No. 1 was established, and fire and police forces have consistently modernized. Lt. Jeffrey Pugh of the Central Pierce Fire Department and Officer Gary Shilley of the Puyallup Police Department typify the professionalism of the current men and women who protect the communities.

Residents supported the building of the nearby US Army and US Air Force bases, and military duty is revered in the communities. Records of deaths from each war poignantly indicate that local youth did not shirk their responsibilities to their country. Included in this chapter are a few who did not return from war, such as Lt. Victor Kandle, US Army, killed in action in World War II and awarded the Medal of Honor posthumously.

In the post World War II years, the communities grew considerably, although not always to good economic or environmental reviews. Largely gone are the truck farms, berry patches, and bulbs. In their place, suburban life with its transportation woes, crowded schools, and increasing infrastructure and service needs make one nostalgic for the seemingly more tranquil, early valley life.

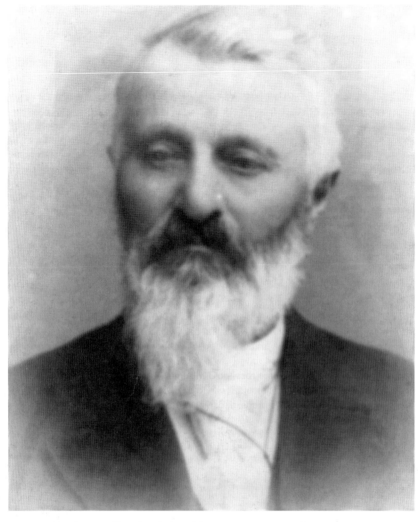

Levant "Fred" Thompson, Territorial and State Representative

Thompson epitomized the restless nature of young men of the 19th century who engaged themselves in various pursuits, succeeding in some, losing in others, but forging on regardless. He arrived in Steilacoom in 1852, where he erected the third sawmill on Puget Sound. In 1855, he received a commission to purchase horses and mules for the regular US Army troops who had become engaged in the Indian War. His recollections of that misbegotten endeavor reveal a series of "Keystone Cop" actions on the part of both Indians and the civilians conscripted to help fight them. At the end of the war, Fred married Susannah Kincaid, daughter of pioneer William Kincaid, and the couple set themselves up in the hotel business. In 1860, the family, which eventually included five children, relocated to property in Sumner provided by William Kincaid. In 1866, they began growing hops and, by 1883, had amassed the wealth to build an elegant home. Fred also provided a $4,000 loan to build the Whitworth Academy. Alas, the Panic of 1893, which caused hops to drop in price from $1 per pound to 18¢, bankrupted the family. Fred moved to Yakima and died in a son's house from pneumonia in 1895. Susannah died a horrible death in 1914 after receiving severe burns when her clothing caught fire. Prior to his death, Fred was remembered for being the oldest living Washington State Representative to have served the first Washington Territorial Legislature in 1854, and again as a state senator in the first Washington State Senate in 1889.

Cassie Pearl Biglow, Puyallup Treasurer

Cassie Pearl, dubbed "Tot" by her family, was born in Ames, Iowa in 1874. Her father, a Civil War veteran, owned a large department store that was instrumental in the education of an African American who gained great fame as a scientist and educator—George Washington Carver. Tot's father allowed Carver, then a university classmate of Tot's, to work for clothing so Carver could stay in school. In 1905, Tot visited Puyallup, loved what she saw, put down roots, and in 1917, became the town treasurer, a position she held for 34 years. An early community preservationist, Tot is also remembered for her large collection of canes. She owned a pistol, and her niece reported that every New Year's Eve at the stroke of midnight, Tot would step out of her imposing home and fire one round. So far as is known, she never struck anyone.

John Rankin Rogers, Washington State Governor

John Rogers, third governor of the State of Washington, was the only Populist Party candidate to be elected to that office in the state's history. In 1890, at the age of 52, Rogers migrated to Puyallup from Maine via Mississippi, Illinois, and Kansas. A businessman, farmer, and newspaper publisher, in Puyallup he owned a drugstore, dabbled in real estate, and resumed his interest in politics. In 1895, he was elected to the Washington State House of Representatives as a member of a relatively new people's party that had split from the Democratic Party. Rogers and his wife, Sarah L. Greene, had five children, and education was especially important to both of them. Early in his tenure, Rogers sponsored House Bill No. 67 titled "Providing for Apportionment of School Fund." This bill, known as the "Barefoot Schoolboy Act," required wealthier counties to contribute more to state educational funds than poorer counties, thus providing equalization for funding schools. The act effectively propelled Rogers to the governor's office in the 1896 election. In 1899, he ran as a Democrat and again secured the office. But one year into his second term, Rogers was stricken by lobar pneumonia and died the day after Christmas in 1901. An imposing man, both in height and in the efficacy of his oratory, Rogers left a treasure trove of speeches, correspondence, and written documents on such commanding topics as the inalienable rights of man, the importance of maintaining strong rural communities, and remedies for involuntary poverty. Two high schools in the state bear allegiance to his name, including the John R. Rogers High School that opened in 1968 on South Hill in the Puyallup School District.

State Senator William H. Paulhamus, "Northwest Builder—Friend of Mankind"
"Northwest Builder—Friend of Mankind" is found on a plaque beneath the portrait of William Paulhamus in the Washington State Historical Society. From his arrival in the valley in 1890, Paulhamus became a man of action. He opened Sumner's first bank, established a berry and dairy farm, organized the Puyallup and Sumner Fruit Growers Association, helped organize and was president of the fair for 20 years, pioneered the freezing of berries, recommended farmers plant bulbs, and helped set up the poultry industry. In 1909, he successfully ran for the Washington State Senate where he became president and succeeded in reducing rail freight fees for farm products, established flood control and road programs, and negotiated anticorruption legislation. During World War I, his company, Paul's Jams, supplied canned jams for US Armed Forces stateside and overseas. Unfortunately, the end of the war meant the end of the market for Paul's Jams, and Paulhamus died in 1925 much reduced in circumstances. At his funeral, the Ku Klux Klan burned a cross, the only reported indication of his membership in this firebrand organization, which appears at odds with his otherwise stellar civic career.

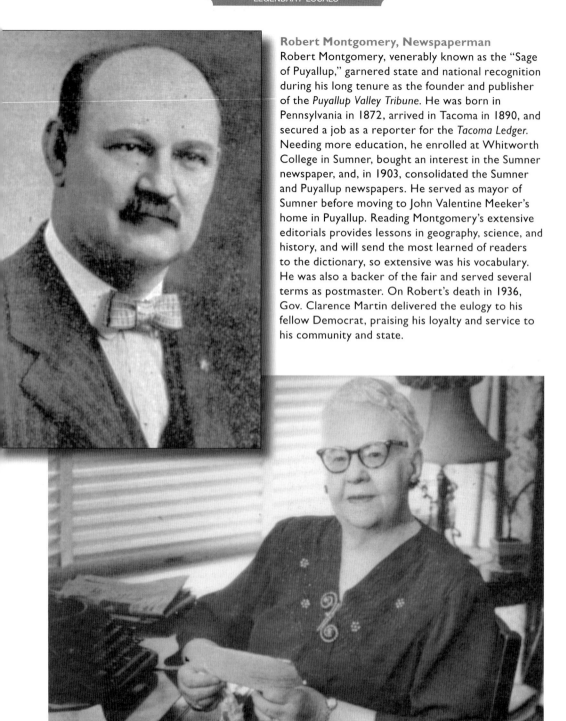

Robert Montgomery, Newspaperman

Robert Montgomery, venerably known as the "Sage of Puyallup," garnered state and national recognition during his long tenure as the founder and publisher of the *Puyallup Valley Tribune*. He was born in Pennsylvania in 1872, arrived in Tacoma in 1890, and secured a job as a reporter for the *Tacoma Ledger*. Needing more education, he enrolled at Whitworth College in Sumner, bought an interest in the Sumner newspaper, and, in 1903, consolidated the Sumner and Puyallup newspapers. He served as mayor of Sumner before moving to John Valentine Meeker's home in Puyallup. Reading Montgomery's extensive editorials provides lessons in geography, science, and history, and will send the most learned of readers to the dictionary, so extensive was his vocabulary. He was also a backer of the fair and served several terms as postmaster. On Robert's death in 1936, Gov. Clarence Martin delivered the eulogy to his fellow Democrat, praising his loyalty and service to his community and state.

Agnes Montgomery

Agnes, an accomplished poet and community participant, helped raise their two children to adulthood—Tom, who succeeded his father as editor and publisher of the *Tribune*, and Marna who married Robert Campbell (see page 73).

Steven R. Gray, Builder and Mayor
Gray left his mark in Puyallup in the several buildings he constructed, including the Elk's Club on north Meridian Street and three buildings for Dr. Warner Karshner. In 1906, he brought his new bride, Rachel Reynolds, to Puyallup where his skills and managerial capacities led to general contracting, and over time, he became the largest contractor in town. A civic-minded Republican in a sympathetic town, Gray was elected mayor three times by 1926, and that year, he served a term in the Washington State Legislature. From 1920, when Rachel died, to 1926, when he remarried Frankie Peters, he raised his two children alone. Gray died in 1954. Grayland Park is named in his honor.

Ruth (Blakeway) Riser, First Woman Member, Puyallup City Council
Ruth, a feisty, no-nonsense woman engaged in the real estate business, won a seat on the Puyallup City Council in 1962, the first woman to do so. Although she insisted on following the law and thus disrupted some of her male colleagues' penchant for using the old boy network, she was highly regarded by her constituency who left her in place for 10 years. Twice during that period she served as mayor pro tem. Ruth's husband, Earl, was an assistant city fire chief, preferring to remain number two so he would not have to put on the public face of fire chief. Ruth served as a "gray lady" Red Cross volunteer during World War II, raised two sons, learned to drive at 50 and to ski at 65, and wielded a hammer to build her retirement home in Gig Harbor. (Courtesy of Clinton Riser.)

Washington State Senator Reuben Knoblauch

Reuben was born in 1914 and served his country in the US Army in World War II. In 1947, he ran for the Washington State Senate in the 25th District, won, and held the position for 30 years. While in the Senate, among many prominent actions, he played a key role in organizing the Seattle World's Fair of 1962. Ever loyal to Sumner, when he died in 1992, he left funds in his will for Heritage Park and an annual scholarship for a high school student. Reuben's tombstone aptly reads, "He served his country, state and church." (Courtesy of Sen. Reuben A. Knoblauch, 1967, by Vibert Jeffers, Susan Parish Photograph Collection, 1889–1990, Washington State Archives.)

Marna (Montgomery) Campbell, Musician, and Robert D. Campbell, Judge
Robert was born in Seattle on Independence Day 1906 and raised in Puyallup. After graduating from the University of Washington Law School in 1931, he practiced law in Puyallup until he was 90. As a lawyer and city judge, he oversaw the properties of many Japanese families forced into internment camps during World War II. Fair officials knew him for his long tenure on their board—from the age of 31 until his death at 94. He was a member of Kiwanis Club for more than 50 years, supported sports teams, and chaired a major gift campaign for Good Samaritan Hospital. Marna put her musical talent to good purposes, teaching and producing operettas before marrying Robert. In addition to raising her sons, David and Richard, she chaired benefits, presided over the orthopedic guild, and was an expert rose gardener, having inherited her green thumb from her father, Robert Montgomery. (Courtesy of David and Richard Campbell.)

Marc Gaspard, Dan Grimm, and George Walk, State Legislators
"Our Native Sons," was the headline of a 1980 campaign mailer for Sen. Marc Gaspard and State Representatives George Walk and Dan Grimm (pictured from left to right). All three were Puyallup High School graduates, with Gaspard in 1966 and Grimm and Walk in 1967. Eight years out of high school, Gaspard won a seat in the Washington State House of Representatives for the 25th District. When Gaspard moved to the Washington State Senate in 1976, Walk and Grimm took the two House seats for the district. All three earned clout in the legislature. Gaspard became Senate majority leader. Walk became House transportation chair, and Grimm was chair of the House Ways and Means Committee. Grimm was elected state treasurer in 1988. Walk spent a long career as director of government relations for Pierce County. Gaspard assumed leadership of the Washington State Higher Education Coordinating Board. (Biographies by Hans Zeiger; photograph, courtesy of George Walk descendants.)

Judith A. (Sannerud) Billings, State Superintendent of Public Instruction
Judith taught at Puyallup's Ballou Junior High, started the alternative high school (now named for E.B. Walker), and obtained a law degree, and in 1987, she was the third woman elected as Washington State superintendent of public instruction. While in office, she helped create a statewide testing system that became the Washington Assessment of Student Learning (WASL). Toward the end of her second term, in 1995, her health began failing, and she was diagnosed with HIV/AIDS, a disease she had contracted through artificial insemination attempts in the early 1980s. In resigning her position, Judith bravely revealed her condition and has become an internationally recognized voice for AIDS testing and intervention. First appointed by Pres. William Clinton to serve on his advisory council on HIV/AIDs, she has held leadership roles on several national and regional AIDS support and foundation boards. She views her experience as both a bombshell and a blessing—a blessing in that she serves as an example of a nontraditional AIDS victim and can help others who are afflicted. Judith continues to promote HIV testing for all routine physical exams and engages youth in civic education through the public legal education organization she cochairs. (Courtesy of Judith Billings.)

Guy "Sam" Colorossi, Orting Mayor and Lahar Event Bridge Proponent
Sam grew up in Orting, a member of the third generation of Colorossis in the community. After graduating from high school in 1957, he went to work for Boeing, rising to first-line management. When he obtained an associate's degree in business aviation, he became a reservations manager for Alaska Airlines and ended his working career as co-supervisor of the Pierce County Ballot by Mail program. From his earliest adult years, Sam has been involved with management of his town and county. He has repeatedly served on the Orting town council, was elected twice as mayor, and helped to fight for the Foothills Rails to Trails project. Sam now spends countless hours developing the engineering concept and financial plan to build the "Bridge for Kids," which would get the schoolchildren to safety should a lahar from Mount Rainier impose a threat. While mayor, he stopped emergency personnel from blowing the lahar siren one night when in fact a nonthreatening rockslide had occurred in the Nisqually, miles away—a very wise decision. (Courtesy of Sam Colorossi.)

Barbara (Ellman) Skinner, Sumner Mayor, and Pierce County Councilwoman
During World War II, Barbara's family moved from Alaska to Sumner where Barbara graduated from high school. After attending business college, she worked for Boeing, met her husband, John, and the couple had three children. When John opened up his own accounting business in Sumner, Barbara became his office manager, a job that gave her insights into community needs. In 1976, she ran for the Sumner City Council, won, and spent 10 years helping to solve problems in the city. Her success led to participation in the statewide organization of cities. In 1986, she successfully ran for the office she had been appointed to on the Pierce County Council, becoming known as "Queen of Garbage" for her efforts to establish environmentally sound county landfills. From 1997 to 2005, she served as mayor of Sumner. Her community involvement is wide-ranging from her church and Mary Bridge Hospital Orthopedic Guild to the Rotary Club and school activities for her grandchildren, the third generation to attend Sumner schools. (Courtesy of Barbara Skinner.)

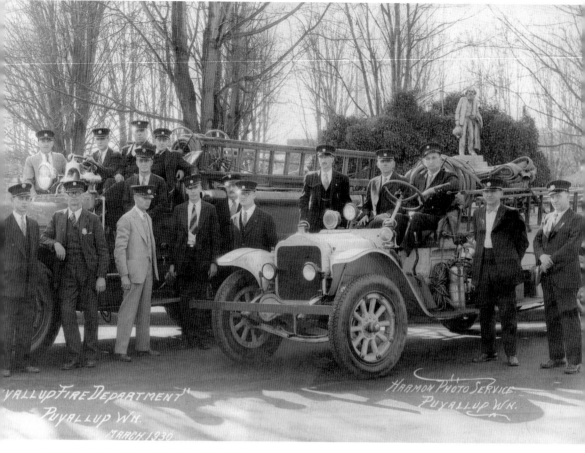

William Mosolf and Unidentified Firemen

William (third from right), George and Theresa Mosolf's bachelor son, became a fireman when urged to that position by town fathers. In a city of wooden buildings with several sawmills, he had his work cut out for him. By 1930, William had become the driver for one of the fire department's trucks. In his memoirs, he recalled kids from his era hunting the many grouse that resided on the property that is now the site of the MultiCare Good Samaritan Hospital complex. William noted that the first pavement was laid on Main Street in 1910 and that jobs were then plentiful in the mills, Northern Pacific Railroad shops, and a meatpacking plant. There were also many opportunities for the workers to relax in a town that offered the thirsty 11 saloons. (Courtesy of Paul H. Karshner Memorial Museum.)

Lt. Jeffrey Pugh, Fire Department Extrication Team Innovator
Shown here in his uniform, Jeff, a lieutenant for the Central Pierce Fire Department, lives and breathes to save lives and to teach others to save lives. In his 20-plus-year career, he has trained in every aspect of firefighting and emergency care, including water, rope, terrorism response, and dealing with hazardous materials. But extraction from mangled vehicles or other confined spaces has become his avocation. He led the effort to establish the Puyallup Extrication Team (PXT), a nonprofit organization offering the only mobile extrication training in the United States. His inventions have enabled the PXT to compete admirably in international and national competitions, and the team has trained firefighters in several states and Guatemala. At home, Jeff sacrifices free time with his family to volunteer for EMPACT Northwest, a charitable organization providing disaster relief and ongoing medical aid to local communities. (Courtesy of Jeff Pugh.)

Chance and Gary Shilley, Puyallup Police Officer
Officer Gary Shilley and his sidekick, Chance, a purebred German shepherd dog, spent more than six years together on the force before Chance's life was accidentally taken during a veterinary procedure. Shilley had always enjoyed training dogs and for many years trained canines as a volunteer for the Tacoma Police Department. In 1991, he was commissioned as a police officer, and two years later, he became a dog trainer-handler. One of 56 commissioned officers now on the Puyallup Police Force, Shilley says German shepherds from Eastern Europe make the best patrol dogs because the instincts are in their genes. In their time together, Chance aided in the capture of 51 lawbreakers, but he was not with Shilley when the officer was shot in the face while investigating the suspicious driver of a vehicle in the South Hill Mall parking lot. Shilley's wife, Shelby, notes that it was maybe a good thing Chance was not there for he might have prevented the emergency responders from tending to her badly injured husband. Such is the loyalty of canine friends who protect, serve the health-impaired, and act as humble companions. This entry is dedicated to the memory of Chance, who was one fine police patrol canine, and in honor of Officer Shilley and all of the men and women who protect citizens in the various communities. (Courtesy of Gary Shilley.)

Memorial Community Center, Puyallup

This community building on Meridian Street was erected following World War II. The following servicemen from the Puyallup Valley represent the many who did not return from the nation's wars. They have the community's eternal gratitude and respect, as do the men and women currently serving in military uniform. The Veterans' Memorial in Pioneer Park in Puyallup contains the names of those who gave the last full measure.

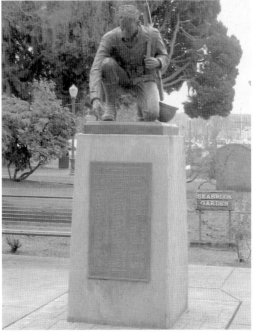

Puyallup's Veterans' Memorial, Pioneer Park, Puyallup

Eunice Gilliam (see page 121) and friends raised funds to build the memorial, dedicated in 2002 to all veterans killed in World War I, World War II, the Korean War, and the Vietnam War. Among the remembered are F3c Thomas B. Hartley (Navy), who died on his ship from the Spanish flu in World War I; Lt. Richard Sloat (Marine Corps), killed in Saipan in World War II; and Pfc. Roland J. Melbye (Marine Corps), killed in the Korean War. Sfc. Nathan R. Chapman (Army), whose family lived in Puyallup, was the first US serviceman killed in Afghanistan.

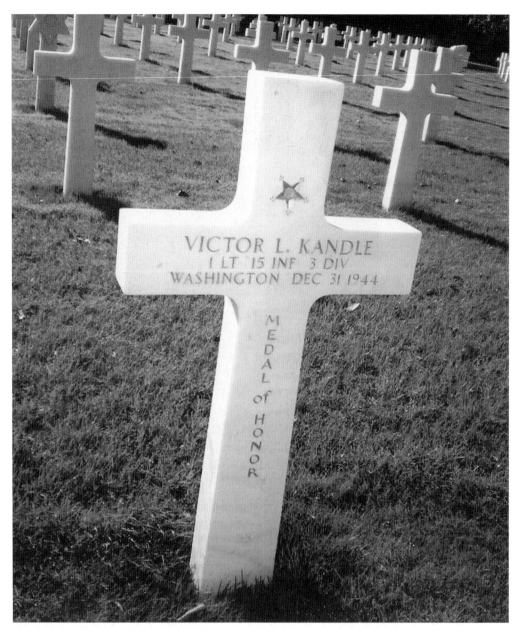

1st Lt. Victor Kandle, Killed in Action, World War II, Awarded Medal of Honor
Lieutenant Kandle, born in Roy, Washington, in 1921, joined the Army in 1940. He was serving with the 15th Infantry Regiment, 3rd Infantry Division on October 9, 1944, near La Forge, France, when his platoon encountered a German stronghold. Lieutenant Kandle engaged in a duel with a German field officer and killed him, then fought his way into the heart of the enemy strongpoint and forced the Germans to surrender. He continued rushing German positions, resulting in the death or capture of 3 German officers and 54 enlisted men, plus the destruction of three enemy stongpoints. Two months later, Lieutenant Kandle was killed in battle. The Medal of Honor, the nation's highest military decoration, was awarded posthumously to his family, then living in Puyallup. Lieutenant Kandle is buried in the American Cemetery, Epinal, France. (Courtesy of Whitney Mullen.)

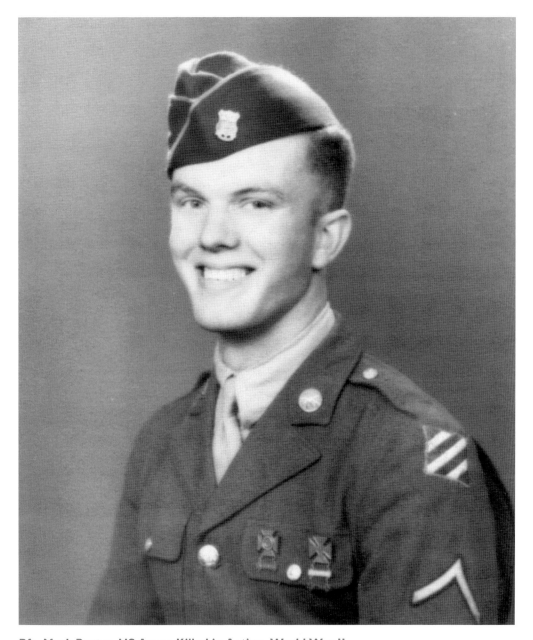

Pfc. Mark Porter, US Army, Killed in Action, World War II
Mark dreamed of a career in journalism. The son of longtime city attorney Marcus Porter (see page 55) and the grandson of pioneers, Porter graduated from Puyallup High School in 1937. He wrote for various newspapers while earning his degree at the College of Puget Sound. In 1941, he joined the US Army on the eve of the Pearl Harbor attacks. In the Army, Pfc. Mark Porter wrote for *Yank* and *Stars and Stripes*, covering the invasions of North Africa, Italy, and France. Serving with Patton's 3rd Army, he chronicled the liberation of Europe. In April 1945, with the war almost over, Pfc. Mark Porter was killed in a bomb blast that rocked the 15th Infantry Division Headquarters in Nuremberg, Germany. Puyallup School superintendent Paul Hanawalt delivered Mark's eulogy. (Biography by Hans Zeiger; photograph courtesy of Betty Porter Dunbar.)

Pfc. Steven Smith, US Army, Killed in Action, Vietnam War
Steven Smith was an aspiring artist who struggled in school but had a rich imagination and sense of humor. In 1965, he dropped out of Puyallup High School in the 10th grade at 17 and joined the US Army, as war was raging in Southeast Asia. Assigned to the 25th Infantry Division, he deployed to Vietnam in December 1965 and took part in fighting above the Viet Cong tunnels at Cu Chi. On April 4, 1966, he was posted on guard duty atop an armored personnel carrier when he was shot by a Viet Cong sniper. Smith was the first son of the Puyallup Valley killed in Vietnam. "Sniper's Bullet Claims Puyallup Baby of 1948 – Only Son in Family," read the headline in the *Pierce County Herald*. His headstone is at Woodbine Cemetery. "That was a tough war for everybody," said Steven's father, Ralph Smith, a World War II veteran, who was given his son's posthumous Purple Heart, Bronze Star, and the South Vietnamese Gallantry Cross with Palm. (Biography, Hans Zeiger; photograph courtesy of Ralph Smith.)

CHAPTER FOUR

Tending to Education and Health

It is fitting to begin the chapter with the efforts undertaken by Eliza Jane Meeker and Elizabeth Spinning to educate citizens on the propriety of women's right to vote. The Washington Territorial Legislature granted women the right to vote in 1883, much earlier than most states. However, the Territorial Supreme Court voided the law a few years later. It took until 1910 for Washington State voters to approve the right, 10 years before all American women were finally granted suffrage.

From the beginning of settlement, teachers and school administrators have loved their community and been revered in return. The earliest biographies on record emphasize school board membership, a custom that continues. In the Puyallup School District, many schools bear the names of key board members. Kalles Junior High School, named for Eileen Kalles, a tireless education proponent, illustrates the practice. Beginning in the 1960s, growth meant a steady increase in the school-age population, leading to tremendous pressure on budgets. From modest beginnings in small, cramped buildings to today's modern, if still crowded, facilities, area school boards, administrators, teachers, staffs, and voters have done their level best to empower students for a productive future.

In the early days, doctors, like John Corliss, saddled their horses and made house calls. Many doctors established their practices in homes that they remodeled. Today, the recently renovated and enlarged MultiCare Good Samaritan Hospital is one of the finest medical facilities in the state. Among other doctors, this chapter features three prominent Puyallup pediatricians, including the first to practice in town, Dr. Paul Gerstmann. He brought Dr. DeMaurice Moses as an associate, and Moses brought Dr. Ovidio Penalver. These men and their families were early contributors to the ethnic diversity that enhances valley life.

Darius Ross and his son Charles donated land in the 1890s from their claim in Puyallup to build a research facility established and managed by Washington State University. The Western Washington Experimental Station initially provided guidance and training in agricultural methods to local farmers. Renowned station researchers, like Dr. Kalkus, have played a major role in the ecology and economy of the region.

Pacific Lutheran University (PLU) was established in nearby Parkland in 1890. Hundreds of valley students, including several of these "legends" have studied there, and many PLU professors, such as Dr. Rodney Swenson, have made the valley their home. College students from foreign countries have learned much about American culture from living in or visiting valley communities.

Eliza Jane Meeker, Puyallup
Pioneer and Suffragette
Eliza, a petite young wife and mother, trudged over the Oregon Trail with Ezra in 1852 and raised five children in a couple of cabins on the present site of Pioneer Park. There she maintained the first lending library in Puyallup. (In 1890, Ezra made it possible for Eliza to build the nicest home in Pierce County east of Tacoma.) Eliza and Elizabeth Spinning acted as co–vice presidents of the Puyallup Woman's Equal Suffrage Association, for a time keeping the suffrage movement alive in the state. In 1890, both Meekers attended the national suffrage convention in Washington, DC, and donated money to the cause. Eliza, unfortunately, did not reap the benefits of her labors, dying with dementia in 1909, one year prior to women achieving the vote in Washington State.

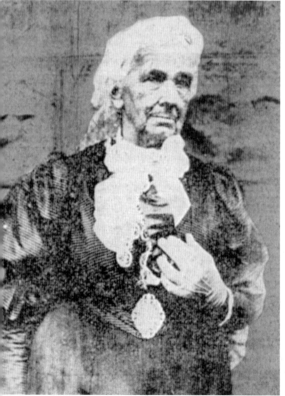

Elizabeth Spinning, Sumner Teacher,
Postmistress, and Suffragette
Unlike Eliza Jane, Elizabeth was formally educated and unencumbered by children when she came to Sumner in 1872 to teach school. Her marital record is not clear, but it is believed she married late and was subsequently divorced leaving no offspring. In 1876, she was the Sumner postmaster for two years. Between 1889 and 1907, she acted as treasurer of the state suffrage association and, in 1908, was made an honorary vice president of the national organization. Happily, she did live to cast votes in the state, not dying until 1916 at the age of 86.

Edmund B. "E.B." Walker, Puyallup School Superintendent, 1908–1920

E.B. Walker instituted the junior high school system for the Puyallup School District when the concept was still under consideration in many parts of the country. A progressive educator, E.B. settled the family in Puyallup in 1903 and, within five years, had become superintendent of the Puyallup School System, a position he held until 1920. E.B. chaired the committee that brought the Carnegie Library to town in 1913 and was active in other civic affairs. Fittingly, when the Puyallup School Board received citizen-approved funding to establish an alternative high school in town, it was named for this early administrator.

Paul Hanawalt, Puyallup School Superintendent for 30 Years

A graduate of the University of Puget Sound, Paul was hired in 1919 to teach middle school math and to serve as assistant principal at Puyallup's combined junior-senior high school. During his administrative years, he put the district on a firm financial footing, even securing federal assistance in the aftermath of the Great Depression. In May 1927, an arsonist set Puyallup High School on fire. At considerable risk to their lives, Paul and a few other teachers managed, barely, to rescue precious records. Today, the high school gymnasium honors his service—the Hanawalt Pavilion. (Biography by Hans Zeiger.)

Sam Peach, Puyallup Superintendent of Schools and Mayor
Sam Peach (second from left) is the only person to have served in both of these positions. Peach was a recent University of Washington graduate when he came to Puyallup to interview with Paul Hanawalt for a teaching job. He was hired to teach junior high and then was an elementary principal. He opened West Junior High School in 1962. Peach served as associate superintendent under Ray Tobiason during a time of rapid growth in the district from 1976 to 1981, at which time Peach became superintendent. When Bill Stoner won a seat on the county council in 1985, Peach was appointed to his city council seat and served for the next six years, including a time as mayor. Peach was a great advocate for parks, youth, and seniors; Sam Peach Park in northwest Puyallup is named in his honor. The other Puyallup School District superintendents pictured here are, from left to right, Herb Berg, 1986–1995; Samuel Peach, 1981–1983; Ray Tobiason, 1975–1981 and 1983–1986; and Tom Terjeson, 1960–1975. (Biography by Hans Zeiger.)

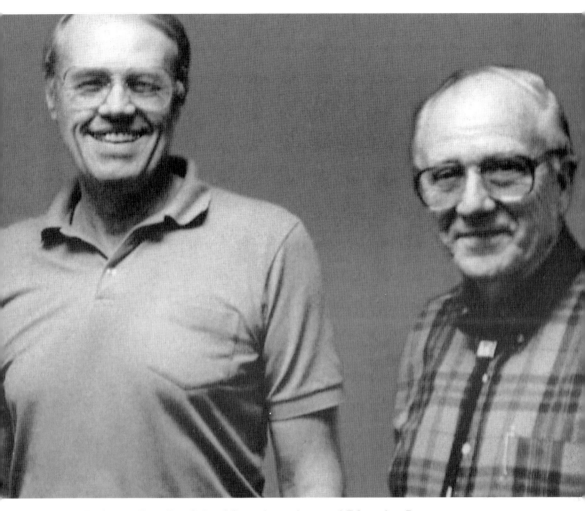

Dr. Ray Tobiason, Puyallup School Superintendent and Education Patron
Born in Longview, Washington, in 1928, Tobiason (second from right) spent a long 52-year career in the field of public education. Puyallup School superintendent Paul Hanawalt hired him in 1951 when Tobiason had just completed his bachelor's degree in education from nearby Pacific Lutheran University. For the next 35 years, Tobiason worked for the district, rising from elementary school teacher to principal to superintendent for the years 1975–1981 and again 1983–1986. During the interim, he was president of Phi Delta Kappa International. Along the way, Tobiason obtained his master's degree in educational administration from PLU and his doctorate in education from the University of Washington. After retiring, Tobiason served in various educational advocacy positions, including 14 years for the Washington Association of School Administrators. His wife, Phyllis, reported for the *Pierce County Herald*, and both enjoyed community life in Puyallup where they raised three children, all of whom became career public school teachers. (Courtesy of Ray Tobiason.)

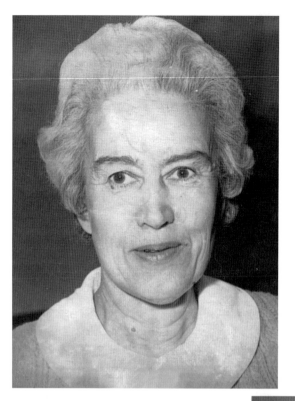

Eileen Kalles, Member, Washington State Board of Education
Eileen Kalles, born in 1915, spent her adult years working to improve the quality of education for schoolchildren, not only in Puyallup, her hometown, but also in the state. She was a 15-year member of the Puyallup School Board and, for nearly 20 years, was on the Washington State Board of Education. According to her daughter, Eileen liked to fish, was a clam digger, led Campfire Girls, and enjoyed a good square dance. In 1970, Puyallup's East Junior High School was renamed in her honor.

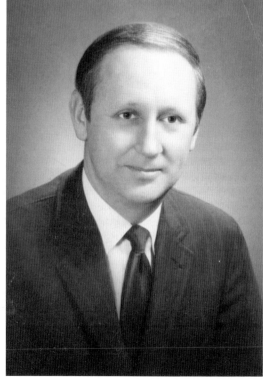

Frank "Buster" Brouillet, State Representative and State Superintendent of Public Instruction
Buster, born in 1928 in Puyallup, became a Puyallup High School teacher in 1955, but the next year, he was elected to the Washington State House of Representatives and continued in that capacity for the next 16 years. In 1973, he was elected as the Washington State superintendent of public instruction and again for three consecutive terms until 1989. Buster was then recruited to establish Pierce College. In 1990, the new elementary school on South Hill was given his name. (Courtesy of Frank B. Brouillet, 1972, Foshaug Studios, State Library Photograph Collection, 1851–1990, Washington State Archives.)

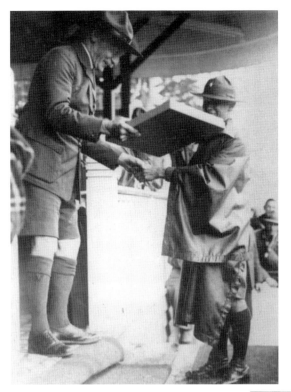

Albert W. Snoke, Puyallup Boy Scout, and Lord Robert Baden-Powell, Scouting Founder
Adam Jonas Snoke arrived in Puyallup in the late 1890s and became the principal of Spinning Elementary School and superintendent of Puyallup schools from 1894 to 1899. His son John Waldo Snoke was a doctor of psychiatry who established a sanitarium on South Hill. When the Snokes' young daughter died of tuberculosis about 1913, Snoke became convinced it was from tubercular cows. He and Dr. Warner Karshner had the cows tested and found that most of the local herds were, in fact, carrying the deadly disease. The cows were euthanized, to the great consternation of dairy farmers, but pasteurization began in earnest across the country due, in no small measure, to Dr. Snoke's intervention. In 1924, John Snoke's son Albert (seen on the right) traveled to the World Scout Jamboree in Copenhagen where he presented the plaque.

Edward Zeiger, Four-time Puyallup School Principal
Edward Zeiger's passion and profession revolved around elementary school children as is evidenced in the three new elementary schools he opened and managed for the Puyallup School District. Zeiger was also a dedicated Boy Scout who worked with the youth for over 50 years, earning their Silver Beaver Award. He still remains busy in his church and with the Kiwanis Club. Zeiger Elementary School, opened in 1996, honors this valley educator. (Courtesy of Hans Zeiger.)

Dr. Charles H. Spinning,
Beloved Doctor to Tribal People

In 1862, the Puyallup Indian Reservation was established to carry out provisions of the postwar treaties. Having naturopathic medical training, Dr. Spinning was appointed as the first doctor to serve the Indian population. Tribal members grew to trust this kind gentleman who spoke Chinook Jargon and treated them with respect. The Spinnings moved rather frequently once they arrived here, living in Tacoma, Puyallup, and, for 10 years, in Sumner before they moved to a daughter's home in Prosser, Washington, where the doctor died at 90 and Mildred at 88. Six of their eight children grew to adulthood.

Dr. John H. "Harry"
and Estelle Corliss,
Circuit Doctor and Legislator

In his courting days, Dr. Corliss saw a picture of a beautiful girl in a photography studio, tracked Estelle down, and made her his bride, and the couple raised four children. About 1894, Dr. Corliss bought a medical practice in Sumner that included horse, saddle, furnishings, and equipment for $100. Ever restless, he ventured to the Klondike during the gold rush, making his money taking care of the miners. Later, the doctor developed a lucrative gravel pit on his property, served in the legislature, and was particularly engaged in his duties as a director of the fair. The Corliss name lives on in ensuing generations of medical professionals. (Courtesy of Josephine Martin.)

Dr. Charles Aylen, General Practitioner

After World War I, Dr. Aylen and his British bride moved to Puyallup where he set up a general practice, one of four doctors in town at the time. He was on the founding medical staff of the Puyallup Valley General Hospital when it opened in 1922 and served on the Puyallup School Board for 12 years in the 1930s and 1940s. In 1970, the new junior high school was given his name. When interviewed in his 88th year, the salty doctor opined the following: "Now everything is so damn scientific. There's a lot of learning to be found in studying the practices of the country doctors of years ago." (Biography by Hans Zeiger; photograph courtesy of Aylen Junior High School.)

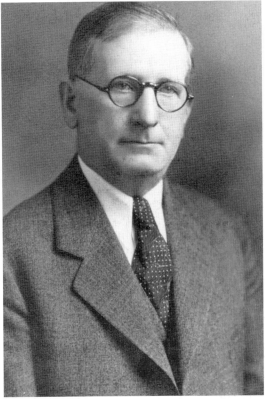

Dr. Albert C. Stewart, Psychiatrist

Albert Stewart was the son of Calvin Stewart. Calvin had been sent West by the Presbyterian Church to help establish the Whitworth Academy in Sumner. Albert attended Whitworth College and Columbia University, and interned at Bellevue Medical School, New York. Following duty overseas in World War I, he became the town doctor in Morton before serving as assistant superintendent at Western State Mental Hospital in Steilacoom and then at American Lake Veterans Hospital. Dr. Stewart followed Dr. John Snoke as director of the Puget Sound Sanitarium. (Courtesy of Laurienne Minnich.)

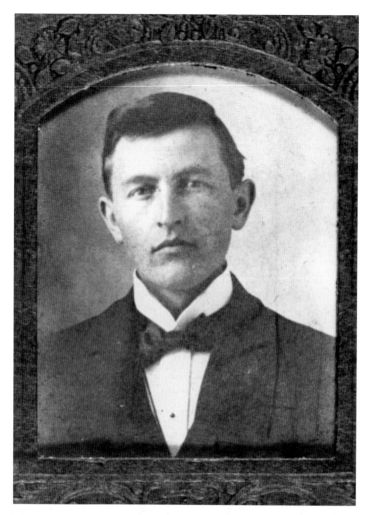

Dr. Warner M. Karshner, Puyallup Public Health Officer and State Legislator
Warner Karshner was Puyallup's second Renaissance man—he was medical doctor, civic builder, state legislator, world traveler, philanthropist, author, and collector. Warner and two fellow male students in 1894 occupied the first men's dormitory at the University of Washington—an abandoned tool shed. Postgraduation, Warner attended Northwestern Medical School and returned to Puyallup, where at various times he fulfilled the duties of public health officer. In 1917, he was elected to the Washington State Senate where he served two terms, with time out in 1919 to don a uniform and report to a unit in Tennessee during World War I. Upon his return, he helped establish the Puyallup General Hospital, the first in the city. Following the untimely death of their 17-year-old son, Paul, in 1924, Warner and his wife, Ella (Hibbert), traveled widely, returning with many artifacts from around the world. In 1930, the couple donated their impressive collection to Puyallup High School, which established a museum named in memory of Paul. Having retired from the pathology department at the University of Washington, Dr. Karshner returned to medical practice in Puyallup during World War II. On his death in 1951, he left many local families mourning the loss of the man who had given so much to the town and who was famous for having owned the first automobile, which braved the mud-clogged streets. Subsequently, one of the elementary schools was named in his honor for his years of service on the school board. (Biography by Hans Zeiger; photograph courtesy of Paul H. Karshner Memorial Museum.)

Dr. Paul Gerstmann, First Pediatrician in Puyallup
Dr. Gerstmann looked after the health of the children of the Puyallup Valley for over 47 years, tending the third generation in many families. He was born in 1924 to German émigrés, who, for many decades, owned a men's clothing store in downtown Puyallup. Following a 22-month tour of duty as a US Navy medical corpsman in World War II, Dr. Gerstmann obtained his medical degree from Northwestern University School of Medicine, Chicago. There, he met Chicago native Martha G. Reichert, married her, and brought her back to Puyallup where they opened the town's first pediatric practice housed in the large Victorian home built for John V. Meeker. The couple raised five children and found time to help establish and support the YMCA to keep youngsters healthy. Dr. Gerstmann loves mountains; he has climbed Mount McKinley in Alaska and scaled his way up Mount Rainier 52 times, the last when he was 69 years old. The twinkle in his eyes when he talks of the mountains leaves little doubt he would still be climbing and skiing if he could. (Courtesy of Dr. Paul and Martha Gerstmann.)

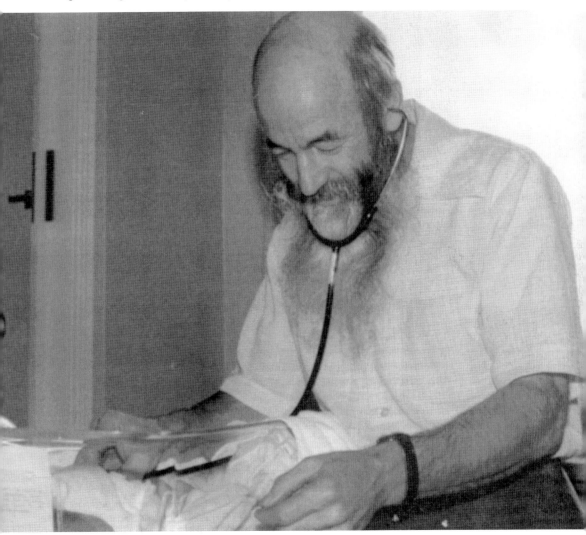

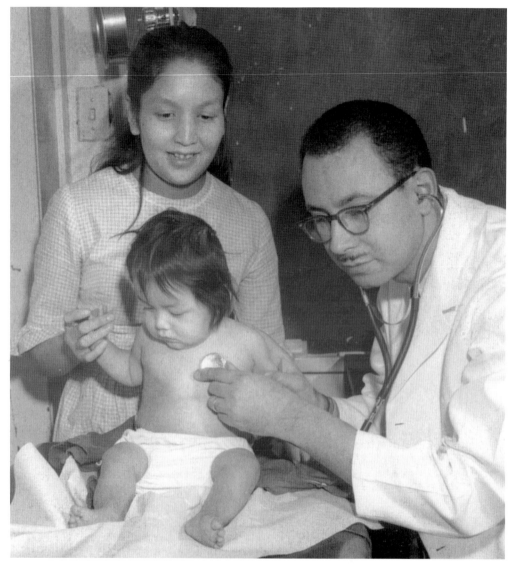

Dr. DeMaurice Moses, Pediatrician, Children's Clinic Developer
Dr. Moses was born in Washington, DC, in 1933. His father was a US Army officer and also a lawyer, and his mother was a teacher. His early years were spent living a segregated life that ended when his father, the only Black commander of a combat battalion in the Pacific during World War II, returned, and DeMaurice began attending school with white children. After graduation from Yale University and medical school at Case Western University, Moses served as a US Army doctor in Germany and came to Puyallup in 1965. Here, he practiced with Dr. Paul Gerstmann in one of the first integrated pediatric affiliations in the nation. Dr. Moses's heart for people from deprived circumstances led to development of the Hilltop Children's Clinic in Tacoma that became part of the renowned Mary Bridge Children's Hospital. Prior to establishment of the emergency ward at Good Samaritan Hospital in Puyallup, he sometimes used his own station wagon as an ambulance. From 1975 to 1976, Dr. Moses was president of the medical staff of Good Samaritan. His wife, Grace, mother of their two children, operated a therapeutic riding school for disabled children. (Courtesy of Tacoma Public Library, D153251.)

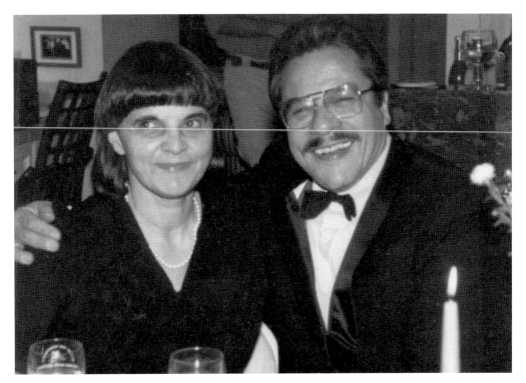

Dr. Ovidio and Margaret Penalver, Catholic Friar, Schoolteacher, and Pediatrician
Born in Havana, Cuba, in 1939, this son of physicians obtained his college degree and then entered a Cuban Franciscan seminary. During the American Bay of Pigs Invasion, the seminary closed, giving Ovidio the impetus to leave the island for New York where he served as a friar for six years. In 1966, he left the order and moved to California with family members where he serendipitously found work teaching high school Spanish. But medicine was in his genes. After achieving his medical degree from the University of Southern California, he undertook his residency with the University of Washington Department of Pediatrics. In 1978, he joined Dr. Moses in Puyallup, and in 1980, Dr. Penalver established his own practice in town, where he still serves his young patients. In California, he married Margaret, and the couple has five children, all pursuing professional careers. Margaret has worked as a school nurse, and both have been very active at All Saints Catholic Church. As Dr. Penalver noted, medicine is just a different form of ministry. (Courtesy of Dr. Ovidio and Margaret Penalver.)

Dr. Donald and Beret "Barrie" Mott, Benefactors
The Motts settled in Puyallup in 1973 where Don established a busy orthopedic surgery practice and assumed leadership roles in the Puyallup Rotary, YMCA board, and Pacific Lutheran University scholarship program. After retiring from surgical practice in 2001, Don became the chief medical officer at Good Samaritan Hospital and was heavily involved in the decision to affiliate with MultiCare that now manages the hospital. Barrie cared for their four children and volunteered for the Medical Auxiliary. Her academic trip to China led to Don traveling there annually from 1995 to 1999 to work with handicapped children. In 2001, the couple helped found the China Partners Network; annually, Don leads teams of physicians and therapists to teach health care workers throughout China. In 2011, Don was selected Laureate of the Greater Tacoma Peace Prize, which granted Don and Barrie the opportunity to attend the Nobel Peace Prize Ceremony in Oslo, Norway. (Courtesy of Dr. Donald Mott.)

Children's Therapy Unit, MultiCare Good Samaritan Hospital
Dr. Mott cochaired the successful $8 million capital campaign that permitted construction of this architectural award-winning building. Shaped like Noah's Ark, the facility houses the world-class Children's Therapy Unit, the largest children's neuromuscular treatment center in Washington State.

Dr. and Mary (Brooks) Ferrucci, Veterinarian

Vitt Ferrucci, a slim man with a huge smile, grew up in the Seattle area, the son of Italian immigrants who operated a truck farm. They also raised mink at a time when the luxuriant fur was an acceptable high-end commodity. Vitt enjoyed working with the animals, and according to his son Skip, Vitt decided to become a veterinarian as a result of caring for the adorable but scrappy little mammals. Following graduation from Washington State University (WSU), he worked for a veterinarian in north Puyallup and then opened his own business on Linden Avenue. He and his wife, Mary, ran the business and raised three children. Vitt maintained an enduring commitment to education, and after being appointed to the Puyallup School Board in 1957, he was reelected nine times before stepping down in 1995 in his 77th year. Ferrucci Junior High School is named in honor of him. From 1980 to 1986, Vitt held a seat on the WSU Board of Regents. Prior to their deaths, the couple endowed a scholarship at the university for teachers advancing their education with preference going to a Puyallup teacher. (Courtesy of Ferrucci descendants.)

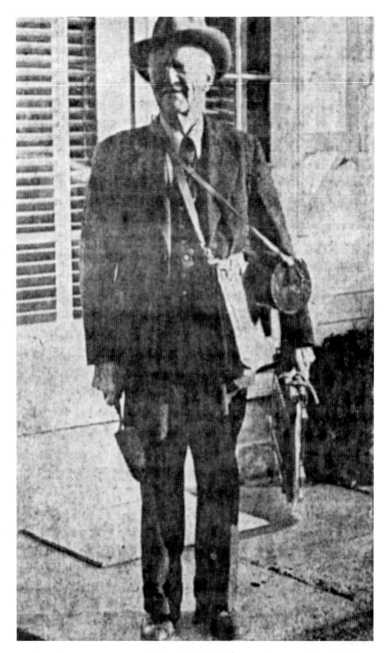

Theophilus H. Scheffer, Northwest Wildlife Scientist
Theophilus was born in 1867 in Pennsylvania, migrated to Kansas with his family, and subsequently received degrees in biology from the University of Kansas in 1895 and from Cornell University in 1898. While working for the US Biological Survey, Scheffer became an expert on Northwest moles, which he admired. He pointed out that it is not the mole that eats plant roots, but trespassers who use their tunnels. Theophilus spent much of his working life with the area's fish and wildlife service, during which time he discovered, on a mountain beaver, the largest and most primitive flea yet known to exist. Named Hystrichopsylla schefferi, the flea is still in the record books. Theophilus lived for 100 years and was active to the end, providing guidance on state wildlife management.

Dr. William A. Linklater, "Kindly, Lovable Citizen"

A member of the fair board wrote this eulogy in memorializing a man who had meant so much to the valley. Linklater came to Puyallup as superintendent of the Western Washington Experimental Station in 1913. An academic to that point, Linklater applied himself to the practical needs of local agriculture, engaging poultry farmers in cooperatives and widening scientific endeavors to aid growers. After William Paulhamus died in 1925, Linklater assumed the presidency of the fair and significantly enhanced its standing in the state. Sadly, in 1937, at 60 years of age, he shot himself with his .22 rifle. The coroner ruled it was suicide, but his friends refused to accept the verdict believing it was an accident. He left a grieving town and a bereaved widow and son.

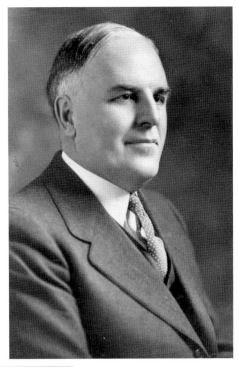

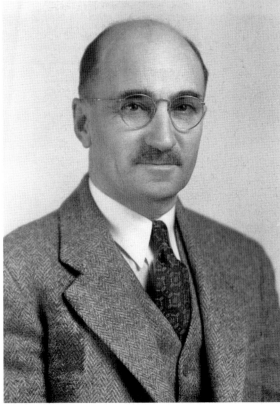

Dr. John W. Kalkus, Research Scientist

Dr. Kalkus is representative of the fine scientists and researchers who have maintained excellence in a variety of disciplines for the Experimental Station. When Kalkus became the director in 1926, he shifted the emphasis from teaching to research. His own specialty became iodine deficiency, and his efforts contributed to the use of iodinization of table salt to prevent goiters. On his watch, several hundred acres were added to the station, and such innovations as open-shed calf housing were found to reduce calf sickness and herd mortality. Dr. Kalkus's long tenure ended in 1953. (Courtesy of MCutcheon's Studio, Puyallup.)

Prof. Rodney and Evelyn (Totzke) Swenson

Rodney hails from northern Minnesota where he was raised on a farm by a family who endured considerable suffering during the Great Depression. He had other ideas for his own future and worked his way through college to obtain a doctoral degree in German and linguistics from the University of Minnesota. In 1957, he married Evelyn, who holds her master of arts degree in library science. Rodney was hired to be the chair of the foreign languages department at Pacific Lutheran University (PLU) in 1968. Their family, including two sons, settled in Puyallup, and Evelyn became a local Cub Scout leader and Rodney a Boy Scout leader, and they remain active at Peace Lutheran Church. In 1975, Rodney assumed responsibility for recruiting PLU students to study abroad under the highly competitive Fulbright program, named for Sen. J. William Fulbright who sponsored the government scholarship legislation. Thanks to Rodney's attentive mentoring, 76 PLU students were awarded overseas study, research, or teaching assistantships over the course of the next 32 years, a most respectable number for a small university. Evelyn retired from her elementary school librarian position with the Puyallup School District in 1998, and two years later, Rodney retired from teaching. As they have for decades, the Swensons continue to open their home to foreign students at PLU, offering them the opportunity to experience the culture and beauty of the valley. (Courtesy of Rodney and Evelyn Swenson.)

CHAPTER FIVE

Enriching
Community Life

In settlement days, many Christian denominations sent missionaries into the area to establish congregations, which met in homes or schools until churches could be built. Diversity in those times was mainly evident in churches. For example, German Lutherans worshipped and socialized in the German-speaking Peace Lutheran Church. Today, the multi-ethnic Foursquare Gospel Church, established by Rev. Tim and Tina Archer, hosts the largest congregation in the valley.

It was not uncommon through the decades into the 1930s to belong to several organizations that aided the community or simply provided entertainment. Each of the communities sported halls built by fraternal clubs for meetings and activities. Some are still used today, such as the Odd Fellows Hall in Orting, while other facilities have either been razed or reclaimed for other purposes. Adults still hold membership in clubs such as Kiwanis, Rotary, and Altrusa, while the youth have had access to Scouting, Campfire Girls, the YMCA, and many other associations.

As the fair grew in importance, influential men sought to become board members. Through the decades, second and third generations of original members have occupied a seat at the table. Recently, Candace Blancher has joined them, the first woman to do so. The grounds now feature year-round venues for events such as gun shows, sewing expos, and three unique fairs.

In 1934, the annual Puyallup Valley Daffodil Festival made its debut. Area high schools select princesses, and from them, a queen to preside over a parade that snakes through the cities of Tacoma, Puyallup, Sumner, and Orting on a hoped-for-sunny Saturday in April.

Puyallup art enthusiast Debora Munson, Rosemarie Eckerson, and colleagues created Valley Arts United in 1995. Sculptures and paintings, such as the one shown in front of the Memorial Building (see page 81), can now be found in various locations, enlivening the gray days for which the Pacific Northwest is known. Sumner High School wisely accommodates a performing arts center, as does the South Hill Pierce Community College campus. In 2004, the City of Puyallup built an enclosed pavilion in the middle of town.

Each community has sponsored sports teams, beginning in the 1880s with adult baseball. Football found a welcome early on in valley schools. Outstanding coaches such as Carl Sparks, for whom the Puyallup stadium is named, provided role modeling for others like Mike Huard, who has coached his own three sons and many others to careers in professional football.

The environmental movement has long been strong in the region. Dr. Ernest Bay, a founder of the Foothills Rails to Trails Coalition, deserves great credit for his tireless efforts to provide safe paths for bicycling, walking, and jogging in the spectacular natural setting.

Rev. Roger and Tina Archer, Foursquare Gospel Church, Puyallup The Archers established the Foursquare Gospel Church in Puyallup in 1998 while still in their youthful 20s. Today, the congregation is by far the largest in the area with 4,000 members. In addition to tending to the community's needy, the church campus incorporates schooling and mentoring programs for youth from cradle to college, including an associate's degree curriculum to train future ministers. Tina leads the ladies' programs from young mothers to seniors. (Courtesy of Rev. Roger and Tina Archer.)

Doris (Leemon) and Stan Michalek, Founders of St. Francis House Doris let no one stand in her way when she was on a mission to help those most in need in her community. She and her husband, Stanley, a US Air Force noncommissioned officer, raised seven children and several foster children while deployed stateside and in Brazil. Stan's final assignment led to their residence in Puyallup. There, in 1974, they established St. Francis House, a facility where collected used items, language instruction, and financial support are made available to the underprivileged. Their daughter Sr. Pat Michalek continues the legacy as executive director. (Courtesy of Sr. Pat Michalek.)

Kiwanis Club Victory Garden Workers, Puyallup, 1943

The Kiwanis Club of Puyallup was founded in 1921 by a group of local civic and business leaders, including Puyallup School District superintendent Bill Gambill, *Puyallup Valley Tribune* publisher Robert Montgomery, confectioner Mike Martin, pharmacist Streator Beall, and clothing store owner William H. Elvins. The club's first major project involved the fundraising and construction of the Pioneer Park wading pool, and club members threw an impressive grand opening for the Puyallup Valley General Hospital in 1922. The club's charitable and philanthropic contributions to the community over the years range from sponsoring scholarships for local high school graduates to grants for Puyallup nonprofits. Two other Puyallup clubs are now in operation, the Sunrisers Kiwanis and the Daffodil Kiwanis. Pictured are, from left to right, (standing on the ground) Fred Pyfer, Glen Cushing, Ruth Meredith, Gus Gross, L.M. Hatch, Floyd Wolberg, Henry Hansen, and Cy Spear; (standing on the truck) Walt Vary, Gordon Bearse, Newell Hunt, and Elwood Hunt. They are preparing to raise vegetables for local consumption in World War II. (Narrative by Hans Zeiger; photograph, courtesy of the Kiwanis Club of Puyallup.)

Altrusa International, Inc., of Puyallup Valley
Chartered in 1948, Altrusa International, Inc., of Puyallup Valley continues to meet community needs. Members are shown here touring Rainier Oncology after knitting hundreds of caps for patients and donating money to help patients pay bills. Altrusa supports the Dental Van, Puyallup Playcare, Family Renewal Shelter, and literacy efforts by collecting books and distributing them via the valley food banks, Parenting Plus, and welfare offices. The club also supplies books to a library in an orphanage in El Salvador, and annually, Altrusa awards scholarships through local high schools. Pictured are, from left to right, Mary Meyer, Beth Harman, Corrie Keltner, Mary Lou Gills, and Gertrude Vailencour. (Narrative and photograph courtesy of Altrusa International, Inc,. of Puyallup Valley.)

Campfire Girls, 1947
The Campfire Girls were ably led from the 1970s to the 1980s by Diane Draper and, for the next 10 years, by Barbara King. Their girls won state and national Arbor Day awards, planted trees at the Karshner School, and engaged in many other civic projects. In 1980, the Campfire Girls from Puyallup and Tacoma raised over $4,400 to purchase a polar bear and enhanced exhibit space for the Point Defiance Zoo in Tacoma. (Courtesy of Barbara King.)

Grace (Hamlin) Corwin, Puyallup Songbird

Grace was born in 1879 in Toledo, Ohio, and began imitating birdsongs as a child. On her own, she learned to execute a perfect trill, an incredible feat. Grace married Fred W. Corwin, and in 1906, the young couple came to Puyallup where Grace became the choir director of the Presbyterian church. Generous with her "lyric soprano" talent, she taught music and participated in the dedication of the first Puyallup Public Library and the opening of the Northern Pacific Train Station. Grace passed away in 1945, her lovely voice now among the angels.

Michael Barovic, Theater Owner, with Bing Crosby

Barovic (left), a strong, cigar-smoking fisherman and longshoreman with a soft heart for the needy, emigrated from a small fishing village on the Adriatic Sea. He built the Constanti Liberty Theater in downtown Puyallup in 1924 and married Constanti's daughter Andrea. In 1939, Barovic bought the Liberty and eventually owned several other theaters. The Liberty featured painted landscape murals, a stage used for vaudeville performances, and the largest screen of its time in the valley. Today, the theater has regained its prominence as an elegant facility for events.

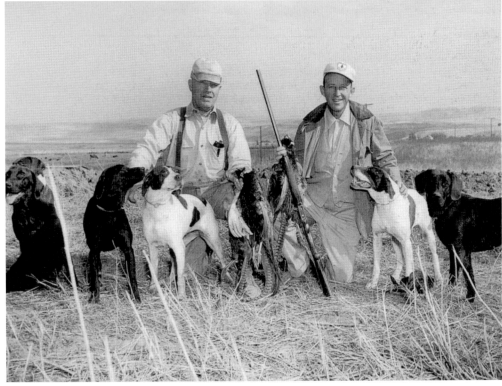

Ruth Meredith, Music Lady, Playing for "Aunt Jemima" Hundreds of Puyallup elementary school students discovered music under the tutelage of Ruth Meredith. She was also the first woman in the Kiwanis Club of Puyallup, joining as "R. Meredith" in 1945. Since music was always included in the club's proceedings, she played the piano. Aunt Jemima, shown here, is believed to be the actress Aylene Lewis; she was headquartered at the Aunt Jemima Restaurant in Disneyland and toured for the company. (Biography by Hans Zeiger, photograph courtesy of Puyallup Kiwanis Club.)

Joseph "Joe" Morris, Versatile Musician
Joe, a former US Navy musician and music teacher, bought Donald McGlenn's music store in Puyallup in 1971. A talented musician and instrument repair expert, Joe taught numerous kids to play various horns. In 1988, he and a small group of musicians assembled a local volunteer band that has flourished with few funds but considerable talent and energy. For the past seven years, Richard Powers, son of the Powers Funeral Parlor family, has conducted this Puyallup Valley Band, which performs 10 concerts a year, including an annual Fourth of July gig on the lawn of the Meeker Mansion. (Courtesy of Joseph Morris.)

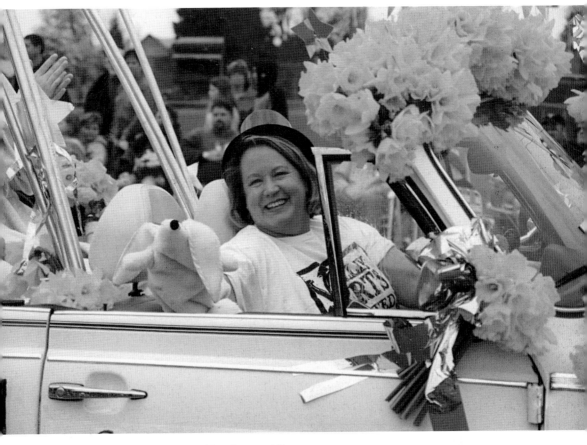

Debora (Stein) Munson, Art Teacher and Promoter
Debora had a heart for art, any kind of art. She lived her passion by educating youth in the arts and providing the community with lasting examples of artistic pursuits. Debora grew up in Tacoma, graduated from the University of Puget Sound, and conducted postgraduate work at the University of Washington. In 1974, she began teaching art at Rogers High School and, for many years, held the position of arts administrator for the Puyallup School District. She helped establish and then chaired Valley Arts United and Arts Downtown. Annually, she participated in the daffodil and Santa parades and, for several years, played the tuba in a local band. Debora loved fireworks, snowflakes, and the stars and moon. Unfortunately, this dynamic wife, mother, teacher, mentor, and friend was taken in 2007, too soon for all who knew and benefitted from her commitment to making her community a more attractive and dynamic place to live. (Narrative and photograph, courtesy of Jenifer Ross.)

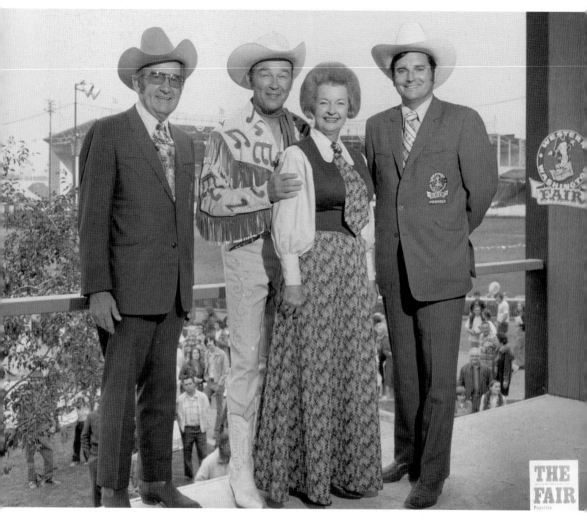

Larry Elvins, Roy Rogers, Dale Evans, Robert "Bob" Carlson, Fair Manager, 1973
After attending a fair in California when yet a young lad, Carlson (far right) knew he wanted to be in charge of such an enterprise. In 1972, he competed successfully to become the chief executive officer of the fair, which in those days featured nine days of displays and activities in September that attracted half a million visitors. Carlson knew they could do better and became the visionary behind the decision to lengthen the fall fair to 17 days, offer both a spring fair and a Victorian Christmas fair, and to enlarge the grounds to accommodate more exhibits and year-round usage. In between the local fair dates, he traveled the country seeking new ideas and engaging entertainers like Bill Cosby, Loretta Lynn, Bob Hope, Crystal Gale, and many other famous performers. When he retired in 2004, the September fair alone brought 1.1 million people to the much-improved grounds. His community leadership in numerous ventures, such as the Masonic lodge, chamber of commerce, daffodil festival, Puyallup Main Street, and Crystal Mountain Ski Resort, is matched by his board presence on various associations including the International Association of Fairs and Expos, where he is a prominent member of its hall of fame. (Courtesy of the Washington State Fair.)

Candace "Candy" (Porter) Blancher, the Fair's First Woman Board Member
Candy is a slight, bright, vivacious woman whose abilities led to her election as the first woman to serve on the fair board of directors. Candace grew up in the valley, graduated from the University of Puget Sound, and was working with her mother's travel company in 1977 when she started a part-time job at the fair. She soon became assistant manager, doing "anything that needed to be done." In 2009, when she retired, she was elected to the board where she has oversight of the Hobby Hall and home displays. From flying airplanes to breeding St. Bernard dogs and managing the chamber of commerce, Candy's background makes her the perfect member to sit on the board of the most prominent community venture in the valley. (Courtesy of Candace Blancher.)

Brittney Henry, Miss Washington 2011
A few caring mentors at Puyallup High School encouraged Brittney to pursue a path to college, despite her unfortunate home circumstances, and their intervention changed her life. She improved her grades, applied for scholarships, and earned money playing her violin at Pike Place Market in Seattle. She graduated from California State University, Sacramento, in 2009 with a degree in intercultural/international communication and organizational communication. Her platform as Miss Washington reflected her own experience, which was higher education for low-income families. (Biography by Hans Zeiger; photograph courtesy of Brittney Henry.)

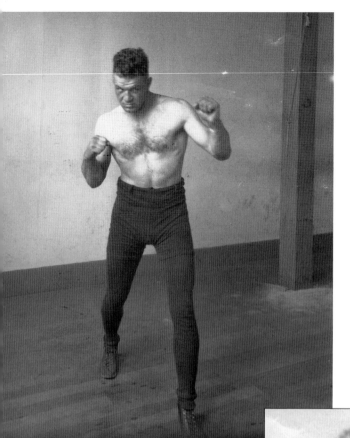

James E. LaFavor, Light Heavyweight Boxer
James, who arrived in Puyallup at the age of five, grew up to become a well-known boxer. Dubbed "Young Jack Dempsey," he fought as a light heavyweight in the 1920s—47 fights in all—and his record was 25 wins (15 by a knockout), 13 losses (he was knocked out six times), and 9 draws. His last fight was in May 1931, following which he settled in Puyallup and went to work for the city maintenance department. He was married to Julia Sulkosky, one of the Sulkosky girls from Sulkosky Lane. (Courtesy of Tacoma Public Library, B13358.)

Wallace "Wally" Staatz, Naval Officer, Farmer, Golf Course and Ski Resort Developer
Following in his father Stanley's footsteps, Wally became a second-generation Orting bulb farmer. After he graduated from college in 1954, Wally ran the farm, known as Roselawn, where he and his dad raised vegetables, berries, and cattle, as well as bulbs. The soil, though, did not prove ideal for growing bulbs, and in 1970, Wally began converting the 270-acre farm into the High Cedars Golf Course, the same year he retired as a lieutenant colonel in the Washington National Guard Reserve. Later, Wally developed homesites adjacent to the golf course and helped to develop and manage the Crystal Mountain Ski Resort. (Courtesy of Jan Mortenson.)

James C. "Jim" Martinson, Vietnam Veteran and Athlete Extraordinaire

As this compendium of memorable people demonstrates, grit, determination, and a "get on with it" attitude kept this valley thriving while other communities lost their way. No entry in this august field so typifies these character traits as that of this Sumner High School graduate and US Army veteran. Jim lost both legs above the knee while serving with the 11th Brigade of the Americal Division in Vietnam in 1968. He counts himself fortunate that his ensuing year-long hospitalization was spent at Madigan Army Medical Center where his family was able to help him recover. After obtaining a degree from Multnomah Bible College, he counseled youths, but sports have dominated his life. He has won the wheelchair division of the Boston Marathon, numerous gold medals in the National Veterans Wheelchair Games, and a gold medal in 1992 at the Paralympics in Albertville, France. Jim is a member of two national halls of fame, to name but a few of his many awards. When he realized that lighter, more flexible wheelchairs would be a huge improvement for competitors and other users, he started a company to manufacture chairs for differing purposes that greatly reduced their weight. Currently, Jim is working with champion golfer Jack Nicklaus and others to raise funds to enhance the American Lake Veterans Golf Course to make it more accessible for wounded warriors. (Courtesy of James Martinson.)

Paul Sulkosky, *Ripley's*
Believe It or Not! **Football Player**
Puyallup student Paul Sulkosky was a fullback
at the University of Washington in the early
1930s, playing both offense and defense. In
1934, he won the Huskies' Season Award.
Ripley's Believe It or Not! subsequently credited
him with never having lost a yard in his four
years of playing. Paul returned to Puyallup after
receiving his education and became a highly
respected banker. He was married to Ruth.
(Gynn) Sulkosky.

Ruth (Gynn) Sulkosky,
Community Leader
Ruth grew up a neighbor to the Meeker
Mansion property, married Paul Sulkosky, and
was secretary of the chamber of commerce
from 1952 to 1966. In 1961, she organized
coffee and food for dazed travelers whose
Seattle train to the Rose Bowl derailed in
Puyallup. After public relations work in
Seattle, Ruth returned to college to get
her degree, which she obtained from the
University of Puget Sound in 1971. Endowed
with boundless energy and productive ideas,
she held leadership positions with the Friends
of the Puyallup Library, Mothers Against Drunk
Driving, the Ezra Meeker Historical Society, and
the Puyallup Valley Women's Republican Club.

Michael "Mike" Huard, Football Coach with Football Sons Damon, Brock, and Luke
Mike Huard, a standout football player, became the coach of the Puyallup High School Vikings in 1981, leading them to 15 winning seasons and four undefeated regular seasons during his 17-year career. For his success, Mike won numerous coaching awards, including recognition by the Seattle Seahawks as State Coach of the Year in 1997. Mike's sons—Damon, Brock, and Luke (pictured from left to right) also excelled at the game in their high school years, and all have gone on to successful football careers. Damon and Brock were the first brothers in the National Football League to start as quarterbacks on the same day. Luke has gained recognition as a college quarterback coach. Not only have the boys benefitted from Mike's tutelage, hundreds of other youths in the area credit their coach for mentoring them to reach their full potential. Mike's wife, Peggy, is the quintessential supportive sports wife, mother, and now grandmother, volunteering in a myriad of youth-related activities. (Biography by Hans Zeiger; photograph by Dick Fichter, courtesy of Huard family.)

Megan (Quann) Jendrick, Gold Medal Swimmer

Megan, an appealing girl with a big smile, graduated Emerald Ridge High School in 2002. An early swimmer, she soon established herself as an unbeatable dynamo. In 2000, she became the youngest medalist on the US Olympic swim team to achieve a gold medal in both the 100-meter breaststroke and 400-meter relay. At the 2008 Summer Olympics, she won a silver medal. In her career, she has set 27 American records and four world records. In addition to raising her family, Megan coaches youth swimming. (Courtesy of MCutcheon's Studio, Puyallup.)

Dane Looker, Retired St. Louis Rams Wide Receiver

Dane was an outstanding football player for Coach Mike Huard at Puyallup High School in the early 1990s. After winning many awards as a wide receiver for the University of Washington Huskies, Dane played professionally for the New England Patriots and then seven years for the St. Louis Rams. Most notable among his achievements was a summer spent playing for the Berlin Thunder in Germany where he led the team to a World Bowl title and was named Most Valuable Player. In 2009, Dane retired from football and entered his family asphalt business. Determined to make a difference in his community, Dane was elected to the Puyallup School Board where he has served since 2011. Dane's wife, Amy (Clancy), is a teacher at Aylen Junior High and girls' basketball coach at Rogers High. The couple has four children. (Courtesy of Dane Looker.)

Michael "Mike" Egan, Microsoft Director and Comedian

Mike Egan has worked for Sen. Patty Murray, Congressman Norm Dicks, and now for Bill Gates at Microsoft, where his title is director of corporate affairs. Before all of that, he was student body president for the Puyallup High School and a member of the class of 1985; he was also student body president at the University of Washington. During his days in the nation's capital, Mike took up a comedy act and was named "Funniest Person in DC." He has frequently spoken at Puyallup High School commencements and serves on several local boards. (Biography by Hans Zeiger; photograph, courtesy of Mike Egan.)

Christopher "Chris" Egan, Sportscaster

After graduating from Puyallup High School, Mike's brother Chris played tennis and basketball at Pacific Lutheran University. A weekly television sports show that he hosted during college launched him into a career in television news throughout the Northwest, first in Idaho and then Oregon. As an anchor for *Northwest Cable News*, he cohosted the Seahawks "Fone Zone" program with fellow Puyallup legend and former Seahawks quarterback Brock Huard. Since 2007, Chris has covered sports for KING 5 television in Seattle. (Biography by Hans Zeiger; photograph, courtesy of Chris Egan.)

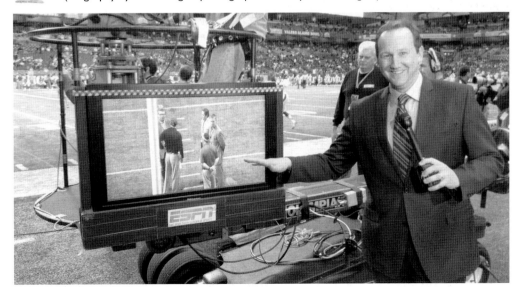

Dr. Ernest Bay, Research Scientist and Trail Proponent
Dr. "Ernie" Bay attributes his interest in trails to his birthplace, Schenectady, New York, because the town's name may mean, "where trails meet" in the local Indian dialect. Growing up in that area, Bay valued local trails along the backwaters of the Mohawk River, but he was frustrated by the private "No Trespassing" signs that thwarted his many forays, and he began dreaming of a bike trail with no such impediments. After obtaining his undergraduate degrees and his doctorate in entomology from Cornell University, Bay taught at the University of California at Riverside, enjoying the Santa Ana trails. A transfer to the University of Maryland found him supporting trail development there before he was selected to head the Western Washington Experimental Station in 1975. His retirement in 1985 boded well for his community. In 1983, the national nonprofit Rails to Trails Conservancy was launched, and Ernie and a small group of proponents began lobbying to convert rails to trails in the valley. With Bay as president, the group formed the Foothills Rails to Trails Coalition and spent long hours developing blueprints, assuaging local homeowner concerns, and rallying after voters failed to pass a bond for the project. When the trail was approved, members rolled up their sleeves to help clear and prepare various sections. Today, the Foothills Trail includes 28 miles of asphalt, ballast, and dirt trails and a 4.1-mile asphalt trail along the Puyallup River. (Photograph by Joan Cronk, courtesy of Dr, Ernest Bay.)

Eunice (Barth) Gilliam, Veterans' Memorial Organizer
Eunice, granddaughter of 1880 pioneers, was born in Puyallup in 1924 and graduated from Puyallup High School in 1942. After moving several times with her Air Force husband, Stan, when they returned to Puyallup and bought their home in 1957, she said, "When I leave this place, it's going to be feet first." Eunice was a volunteer extraordinaire, advocating for those who had no one to speak for them, collecting soap for third-world countries, and spearheading the effort to create the Veterans' Memorial. She died in 2007 in her own bed where her daughter Chris had cared for her after the death of Stan in 2004. (Courtesy of Chris Nimick.)

Lori (Long) Price, Puyallup Historian
Lori came to Puyallup as a military wife in 1958 and spent the next 49 years of her life becoming the city's most venerated historian. Traveling the world with US Air Force husband, Earl, and their four children whetted Lori's interest in the culture of each locale they inhabited. Once settled in Puyallup, Lori started learning about the valley and began writing articles for the *Pierce County Herald*. In 1986, the City of Puyallup named her Honorary Historian, and in 2002, she coauthored the definitive history of the town. Lori's untimely death in 2007 left a huge void, but her legacy lives on in the many articles she prepared and in her extensive photographic collection, both of which have been archived by Meeker Society volunteers.

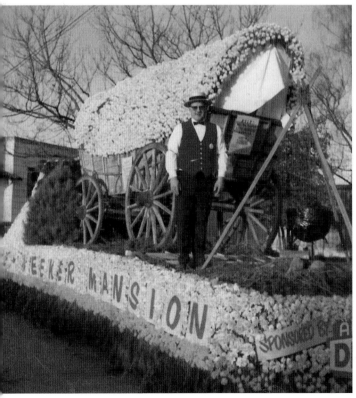

Robert "Bob" Ujick, Meeker Mansion Preservationist
Robert Ujick, born in Puyallup in 1930, became a butcher and ardent preservationist of the historic Meeker Mansion. Shortly after the Meeker Historical Society took possession of the mansion, Bob became an indispensable volunteer. He donated period furnishings, asserted his views on every preservation undertaking, suffered through the three arson fires, made countless pots of coffee, collected cardboard around town for years to be sold for scrap to raise funds, and served as the memory bank for what must have seemed to him an endless stream of administrators.

Hazel Hood, Record Keeper

Hazel Hood was born in Centralia in 1913 and married Charles Hood, son of Charles Hood (page 45), one of Ezra Meeker's business partners. Hazel was in on the beginning of the drive to save the Meeker Mansion and, for many, many years, served as correspondence secretary, registrar, curator, and recorder of the history of the society and town. It was she who wrote the letters to local families seeking information that led to the publication of the "Pacemaker" articles used for this book. Active in societal affairs almost until her death in 2011, she was especially noted for eliciting good stories out of old-timers.

Laurienne "Laurie" (Stewart) Minnich, Meeker Mansion Volunteer

Laurie grew up in Puyallup in a home adjacent to her father's psychiatric sanitarium (page 93). She married Scott Minnich, a US Air Force officer, and the couple frequently moved with their three children, until Scott retired to Puyallup. Laurie has been a volunteer at the Meeker Mansion for 40 years, during which time she has conducted tours, organized teas, and helped the historian and curator accurately record the society's holdings. Her son Robert is currently president of the Puyallup Historical Society at Meeker Mansion. (Courtesy of Laurienne Minnich.)

John Kenneth "Ken" Keigley, Meeker Genealogist

Ken Keigley, great-grandson of John Valentine Meeker and great-grandnephew of Ezra Meeker, possessed a phenomenal memory. For example, he remembered that when he was five years old, Ezra took him for ice cream. Ken played in a band until he married, at which time he quit to spend evenings with his wife. He worked at Todd Shipyards during World War II and then as an electronics instructor at Bates Technical College. In retirement, he became the self-appointed genealogist of the Meeker family. At the time of his death in 2012, at nearly 101 years of age, he had managed to document more than 55,000 Meekers in his computerized genealogy. He was mentally alert to the end, and to spend time with Ken was to return to the days when life in the valley revolved around simpler pleasures.

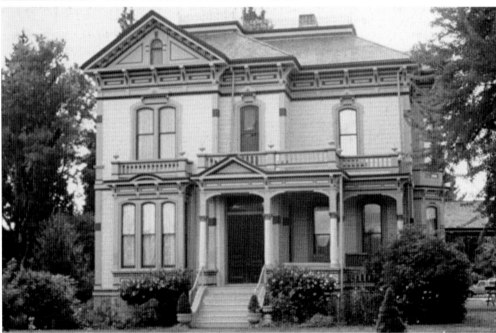

Restored Meeker Mansion

Here is the Meekers' old home as it appears today. The building is open to the public for tours and may be rented for special occasions. See www.meekermansion.org. (Photograph by John Snope.)

BIBLIOGRAPHY

Bonney, W.P. *History of Pierce County Washington, Vols. I–II*. Chicago, IL: Pioneer Historical Publishing Company, 1927.

Dummond, Val. *Doin' the Puyallup: An Illustrated History of the Western Washington Fair Since 1900*. Puyallup, WA: Western Washington Fair Association, 1991.

Evans, Jack R. *Little Histories: Levant F. Thompson, Hop King, Banker, Senator, Pierce County, Washington, Pioneer*. Seattle, WA: SCW Publications, 1992.

Gould, Charles J. *History of the Flower Bulb in Washington State*. Mount Vernon, WA: Northwest Bulb Growers Association, 1993.

Larsen Dennis M. *The Missing Chapters: The Untold Story of Ezra Meeker's Old Oregon Trail Monument Expedition January 1906–July 1908*. Puyallup, WA: Ezra Meeker Historical Society, 2006.

Meeker, Ezra. *Pioneer Reminiscences of Puget Sound: The Tragedy of Leschi*. Seattle, WA: Lowman & Hanford, 1905.

Morgan, Murray. *Puget's Sound, A Narrative of Early Tacoma and the Southern Sound*. Seattle, WA: University of Washington Press, 1979.

Price, Lori. and Anderson, Ruth, *Puyallup, Pioneer Paradise*. Charleston, SC: Arcadia Publishing, 2002.

Rushton, Alice. *The History of the Town of Orting*. Orting, WA: Heritage Quest, 1989.

Ryan, Amy M. *The Sumner Story*. Sumner, WA: Sumner Historical Society, 1988.

INDEX

Find more books like this at
www.legendarylocals.com

Discover more local and regional history books at
www.arcadiapublishing.com